JEANETTE PASIN SLOAN

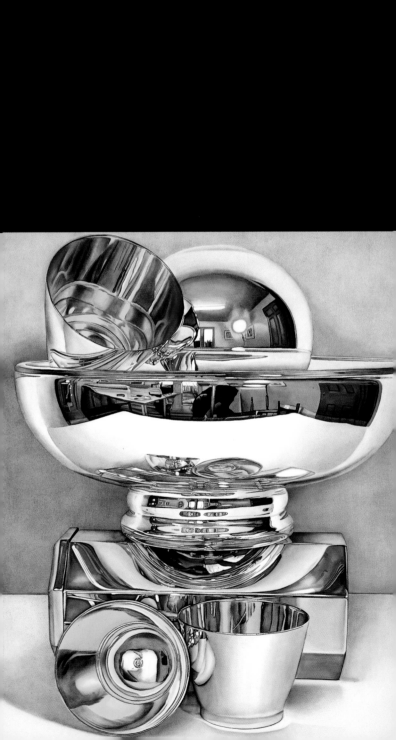

JEANETTE PASIN SLOAN

BY GERRIT HENRY

HUDSON HILLS PRESS ■ NEW YORK

The artist and publisher wish to express their appreciation to the following for their support of this publication: Kathryn Basil, Susan Berger, Bryna and Ed Gamson, Jack Lemon, Russell Novak, Mario A. Pasin, Cissy Peltz, John Szoke, Doris and Bob Thimmesh, and Gerhard Wurzer. The photographs are by Michael Tropea and Tom Van Eynde.

FIRST EDITION

Published in the United States by Hudson Hills Press, Inc., 1133 Broadway, Suite 1301, New York, NY 10010-8001.

Distributed in the United States, its territories and possessions, and Canada by National Book Network.

EDITOR AND PUBLISHER: Paul Anbinder

MANUSCRIPT EDITORS: Phil Freshman and Susan Curvin Jones

PROOFREADER: Lydia Edwards

INDEXER: Karla J. Knight

DESIGNER: Betty Binns

COMPOSITION: Angela Taormina

Manufactured in Japan by Toppan Printing Company

LIBRARY OF CONGRESS CATALOGUING-IN-PUBLICATION DATA
Henry, Gerrit.
 Jeanette Pasin Sloan / Gerrit Henry.– 1st ed.
 p. cm.
 Includes bibliographical references and index.
 ISBN: 1-55595-189-9 (cloth: alk. paper)
 1. Sloan, Jeanette Pasin, 1946–—Criticism and interpretation. 2. Still-life in art. I. Sloan, Jeanette Pasin, 1946– II. Title.
 N6537.S568 H46 2000
 759.13—dc21
 00-40964

CONTENTS

ILLUSTRATIONS

Works marked with an asterisk (*) are reproduced in color.

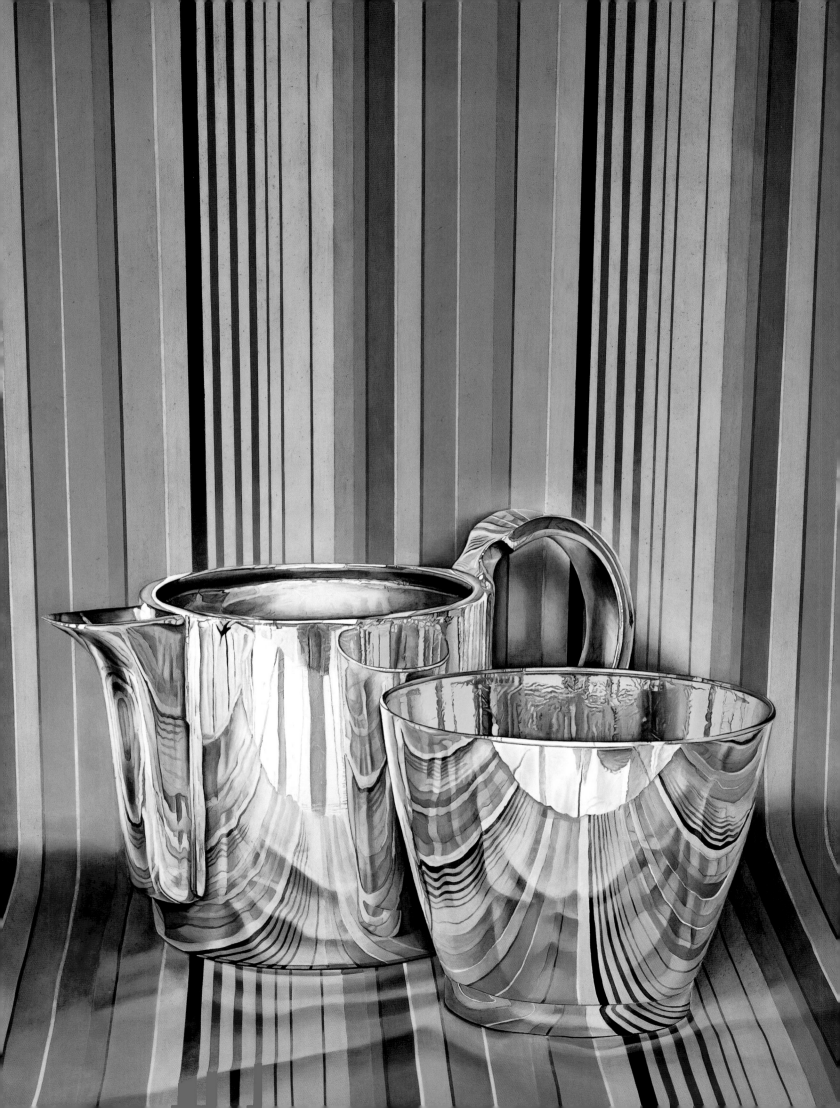

REFLECTIONS IN A SILVER EYE

GERRIT HENRY

Still-life painting in Western culture has had a long, if sometimes ignoble, history. As early as the third century B.C., the Etruscans painted reliefs of tools, weapons, and kitchen utensils in their caves. And from the first century B.C. to the first century A.D., the Romans were artfully depicting mundane items in their frescoes.[1]

Medieval and Gothic artists emphasized the immaterial and the celestial, while pointedly downplaying the value of earthly objects. Perhaps the first important reappearance of still life in the West occurred during the Northern Renaissance, when Robert Campin (the Master of Flémalle) composed his three-paneled *Mérode Altarpiece* (c. 1425–28) to include roses, violets, and daisies; a hanging basin and a towel on a rack; a just-extinguished candle and a vase with a lily on a table; and mousetraps. Significantly, the artist was painstaking in his attention to the realistic details of these inanimate objects, each of which had a religious referent.[2]

Despite its popularity over time, still life traditionally fell last in the accepted hierarchy of genres, following history and religious painting. But in seventeenth-century Holland, such artists as Willem Claesz. Heda and Jan Davidsz. de Heem elevated still-life painting to new heights.[3] Now, when a more secular attitude prevailed, religious symbolism in art gave way to more realistic renderings of the material world. For example, a gloriously Baroque flower painting by de Heem might also contain snails, butterflies, and

JEANETTE PASIN SLOAN 9

MACCHI'S STILL LIFE 1987, Oil on linen, 56 × 40 in. Margaret Charlton

moths—all of a subtly significant, otherworldly nature—while a Heda still life, replete with shiny silver plates, glistening crystal goblets, and the remains of a hearty meal, could hint at the inevitable passage of time and pleasure.[4] In seventeenth-century France, Jean-Baptiste-Siméon Chardin was painting domestic still lifes that epitomized the genre. His mute, glowing arrangements of familiar items—crockery, pans, fish, and eggs—glorify the ordinary and the everyday.

In America during the nineteenth century, still-life painting was relegated to second-class status, except for the trompe l'oeil works of William M. Harnett and the meticulous renderings of discarded objects by John Frederick Peto.

Not until the 1960s, in New York City, did still-life painting attract attention and an enthusiastic following. Pop artists such as Robert Rauschenberg and especially Andy Warhol stirred up an interest in the banal, much as Harnett and Peto had done a century earlier. The effect, however, was now baldly ironic, not humble or modest. Actually, the explosion of Pop art, exemplified by Warhol's photographic soup cans, was preceded, in the 1950s, by the painterly realism of Nell Blaine, Jane Freilicher, and Fairfield Porter. And it has been succeeded by the more naturalistic still-life style of artists such as William Bailey, Janet Fish, Audrey Flack, and Raymond Han.

Not coincidentally, it was during the last three decades of the twentieth century that the American artist Jeanette Pasin Sloan adopted—and continues to adopt—the humble spirit of still life to her own ends. Unlike some of her peers, however, Pasin Sloan sees little link between her still lifes and those of the past. "When I was in high school and college," she says, "I often went to Italy with my parents, who had a home there. I saw a lot of the Venetians—Titian, Veronese. The color, the composition—those had a great impact. Finally, though, I was more influenced by modernism. I love the sense of design and color, the bold shapes, the formalism of the moderns."[5]

Yet she is not so much in love with modernism as to have completely excluded from her work the fundamental beauty of still life—its recognition, appreciation, and celebration of simple material objects. But the scene-distorting reflections on the surfaces of Pasin Sloan's otherwise placid, silver-sheen pitchers, her gleaming Revere Ware bowls, her cheap silvery cups and shiny cigarette boxes may convey a more cryptic message about the seductiveness of the sorts of things that represent pleasing comforts in an upper-middle-class home.

"In the beginning," Pasin Sloan says, "the distortions were unconscious. They've become much more conscious now. But I've always thought that my best work was right on the edge of disorder. I think it's as much about disorder as it is about harmony and balance."

J eanette Pasin was born in Chicago on March 18, 1946.[6] Her father, Antonio, had immigrated to America at age fifteen from the small northern Italian village of Rosa, on the outskirts of the walled, medieval city of Bassano del Grappa. His father had been a carpenter, and Antonio would soon take up the trade in his new home.

"He was an amazing man," his daughter recalls. "He traveled to America alone in 1919, went through Ellis Island, came to Chicago, and did a variety of odd jobs to stay afloat. At some point, after work each night, he started making Victrola cabinets. He would go around Chicago and sell them. Then he started making wooden wagons, which he would also sell."

Eventually, Antonio Pasin became friendly with some men in the scrap-metal business, and he started making his children's wagons out of steel. The result of these new friendships, coupled with his carpentry skills, was the extraordinarily popular Radio Flyer coaster wagon, of which hundreds of thousands were sold. According to Pasin Sloan, her father named his creation after meeting his countryman Guglielmo Marconi, inventor of the wireless, aboard a ship that was taking them both back to Italy for a visit. Like the airplane, the radio was a revolutionary new invention. So what better name for a state-of-the-art wagon than Radio Flyer!

In 1929, on one of his frequent trips back to Italy, Antonio met Anna Baggio, who worked in her family's grocery store–bakery in Rosa. Soon after their wedding, the young couple traveled back to Chicago "just for the honeymoon." But instead of returning to Italy, where they intended to settle, they spent the rest of their lives in the Midwest; Antonio felt he had to stay there in order to run his business.

Three children were born to the Pasins. First came twins—a boy, Mario and a girl, Mary Ann—and then, sixteen years later, Jeanette. Today, the artist describes her childhood as lonely, probably because of the ages of both her parents and her siblings. Yet she also has fond memories of the family's frequent trips to Bassano del Grappa, a city with a populace of about sixty thousand, near her father's birthplace. Determined to maintain their ties

with Italy, the senior Pasins had a villa built there. Also, their youngest child grew up speaking Italian as a second language.

Even as a youngster, growing up in the Chicago suburb of Oak Park, Jeanette found solace in quiet, solitary activities. "All I wanted to do was color and draw," she recalls. "Every time I went to the dime store, I'd get a coloring book or a cutout book." Then, in adolescence, she developed a new consuming passion: "By the time I reached high school, my goal was to become a saint. My favorite nighttime reading was *Lives of the Saints.* But if you weren't willing to have yourself martyred, you'd never cut it! It set weird standards. I always felt like the consummate sinner. I attended mass almost every day in high school."

Jeanette did not excel academically at Trinity School, where her teachers were Dominican nuns. Instead, she focused her energies on drawing illustrations for the school's literary magazine, and, not surprisingly, she took every art class she could.

Although Pasin Sloan now claims that she had been "a very nerdy kid and the second-tallest girl in the class," one who "never dated anybody" because her parents were so strict, she also has fond memories of youthful friendships and activities. "We'd go downtown on the El on Saturdays, to this great little shop where they had imported cigarettes. I always smoked. That was my one rebellion. We'd go to this dumpy place—it's still on Michigan Avenue, across the street from the Art Institute—called The Artists' Snackshop, and we'd talk about the meaning of life and religious matters." It was also at this time that she developed what was to become an enduring passion for reading.

During her senior year at Trinity, Jeanette decided to compete for a scholarship to the School of the Art Institute of Chicago, a process that involved, in part, spending a full Saturday drawing from models at the museum. "I *got* a scholarship," she says, "but I had grown up so strict and so Catholic, that going to an art school just seemed too alien an experience for me. I thought I wanted a liberal arts education, and I've never regretted that. But that limited me to choosing from among just three or four Catholic women's schools." Her final choice did indeed provide a liberal arts—as well as a liberating—education.

In retrospect, Jeanette Pasin Sloan acknowledges that her mother and father played a formative role in her development as an artist. "When I was in high school, my parents built a very modern house," she relates. "I didn't like it because it was so stark, and my idea of the real American life was East Coast colonial. But I think that was a

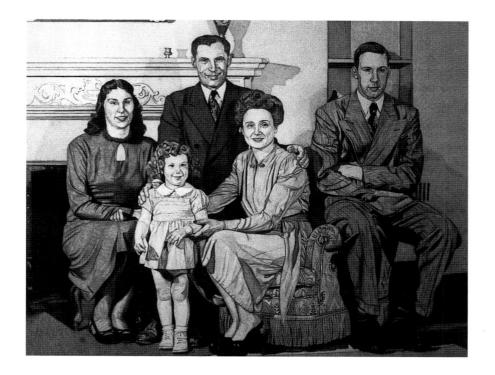

big influence, growing up in a house that was so modern, so severe. My parents had a tremendous amount of style and taste. I don't know where it came from, but it wasn't the Italo-American look at all. My mom would take weeks searching out the right bathroom glass, the right towel. Every object was important. That was a great influence on me—the strength of what an object can mean."

There was influence from the paternal side as well—if not exactly aesthetic, then at least richly symbolic. "The Radio Flyer wagon," Pasin Sloan laughs, "was a ubiquitous presence in my life! It was such a great object, carrying so much weight for so many people. My dad even had a building in the 1933 Chicago World's Fair; it was in the shape of a wagon with a little boy in it. That wagon is a significant icon."

Jeanette entered Marymount College in Tarrytown, New York, in 1964. She brought to this all-female Catholic institution her high school bohemianism and her growing intellectual curiosity. She took classes in existentialism and comparative religion, read the works of Kierkegaard and other provocative philosophers, and discovered that even at this sedate and staunchly middle-class women's school drug use was not unknown. A woman who taught existential philosophy at Marymount, Jean Houston, wrote a book, *The Varieties of Psychedelic Experience* (1966), that was an influential work on LSD. "I remember feeling

like a real wimp," says Pasin Sloan, "because I never used drugs. Houston believed that using LSD could be like a religious experience."

Instead of illegal drugs, Pasin Sloan embraced the political radicalism of the time. Her involvement in campus politics led to her election as president of her sophomore and senior classes. But art remained her first love. She took nearly all her art history classes with Sister Elizabeth McAllister, who was involved both politically and romantically with the radical Jesuit priest Philip Berrigan, brother of the better-known Daniel. (Subsequently, the couple left their respective religious orders and became man and wife.)

Sister Elizabeth encouraged Jeanette to support anti–Vietnam War activities. The student and her teacher went to New York City to hear Dr. Benjamin Spock, then at the height of his political activism, speak against the war. Inspired, Jeanette would go on "fasts for peace" that generally lasted a couple of days.

During two summer vacations in a row, she took beginners' courses at the Art Institute of Chicago, one in figure drawing and the other in intaglio printmaking. Clearly, her artistic impulse remained strong, despite some of the distractions provided by college and her exposure to a less cloistered world. Nonetheless, she was not consciously planning for a career as an artist. Speaking of herself and her friends at Marymount, she says: "We wanted the careers, but I don't think it ever dawned on us that we had to make a choice, whether to marry, whether or not to have children. In those days, you couldn't do both. When I grew up, you were not raised with a lot of options: you were raised to be a mother and a wife."

And that is exactly what Jeanette Pasin would soon become. James Park Sloan, the man she would marry, was born in the small town of Clinton, South Carolina, and admitted to Harvard at age sixteen. After his sophomore year, Sloan voluntarily joined the U.S. Army and eventually served as a Green Beret in Vietnam. By the time he returned to Harvard from active duty, Jeanette, whom he had met three years earlier, was a senior at Marymount. "Even though I was deeply involved in the peace movement," says Pasin Sloan, "I was getting a very different perspective on things when I started dating Jim in my senior year."

She also was thinking more about life following graduation. "I figured that if I pursued art history, it would be something 'real' to do with my life—maybe teach at a small college," she recalls. Of the six graduate schools to which she applied, four offered studio programs; but those four rejected Jeanette Pasin because of her limited portfolio. She was, however, accepted by the University of Chicago in art history, a turn of events that amazed

her: "The U. of C. seemed so exotic to me after all these not-so-top-of-the-line Catholic schools."

At the university, she met her first true guide, the art historian and writer Joshua Taylor, who was then a professor of American art. She did an independent-study project with him on the history of American printmaking and remembers him as "a wonderful mentor. I was very nervous about my intellectual ability, but he always made me feel comfortable. He made me feel, for the first time in my life, that it was possible to hang around somebody who was really bright."

Meanwhile, the relationship with James Park Sloan was growing more intense. By the time he received his undergraduate degree from Harvard, he had secured an option from Houghton Mifflin on a novel he was writing, *War Games*. Published in 1971, the book received favorable reviews, several critics even seeing in Sloan the makings of a great American author. Back in Chicago, Jeanette had completed a year of graduate school and had decided to switch from art history to studio arts. Now her primary instructor was the printmaker and artist Max Kahn.[7] (She would receive her M.F.A. in 1969.)

In July 1968 Jeanette and James married, and the young couple began their life together in Cambridge, Massachusetts. James, who wanted to be a businessman as well as a writer, entered a doctoral program at the Harvard Business School.

After living for six months at Peabody Terrace, a Harvard housing facility for married students, the Sloans moved to the town of Belmont, near Cambridge. Pasin Sloan started doing illustrations—"black-and-white, very simple, very stylized"—for a series of Spanish-language textbooks published by the Lexington, Massachusetts–based D. C. Heath and Company.

The couple's first child, Eugene, was born in May 1969. That fall, Pasin Sloan started teaching art at Winchester High School, near Belmont. The next year she was pregnant again; a daughter, Anna, was born in January 1971. In 1972 the young family moved to Jeanette's hometown, Oak Park, after James, who had left the Harvard Business School program to spend more time writing, accepted an offer to teach creative writing on the Chicago campus of the University of Illinois. He had gotten the job on the strength not only of *War Games* but also on that of his second novel, *The Case History of Comrade V.* (1972). Although both books were critically well received, neither one became a best seller.

Back "home" in the Upper Midwest, Pasin Sloan had difficulty finding work. Freelance illustrating jobs were at a premium in Chicago, and she was uncertain of how, or even where, to proceed. "I had no role models," she says. "I didn't know anyone who had kids and was an artist. In fact, none of my friends were having kids at all. I ran the gamut of things I was vaguely interested in. I tried to do some artwork, but I didn't have much skill.

"Also, I kept thinking about artwork being ideas—to be a great artist, I thought, you really had to come up with something new, in terms of both subject and style. I did a series of horrendous pieces—illustrations where I was trying to depict things going on in people's brains. That didn't work."

Finally, her husband suggested that she spend a couple of years simply painting and drawing what was around her in the house. She agreed to try this new approach and soon settled into a routine: she devoted the daytime to her children and the nighttime to her art. As soon as Eugene and Anna had gone to bed at 7:30, Pasin Sloan would sit at the small kitchen table, surrounded by coffee, cigarettes, acrylics, brushes, and pencils. Then she would paint the mundane objects that surrounded her, the props of her everyday life—a high chair, an air conditioner (page 38), a small black-and-white portable television (page 37)—often working until 3 or 4 A.M.

At last, it seemed, Pasin Sloan had found her métier. Now, she had to fine-tune it. "I would pore over *American Artist* magazine to learn technique. I knew a dorky old lady, a Sunday painter, whom I'd call and ask, 'How do you paint the color *chrome?*'" The results, evident in *High Chair* (1973, page 37), anticipate to some extent the dead-on views of things that she would eventually favor. Then, in 1975, she painted *Toaster* (page 38) and was struck by the reflection on its surface. To Pasin Sloan, the depiction of reflections presented an intriguing technical challenge, one that she would confront in numerous subsequent works.

The artist's initial attempts to exhibit and sell her paintings, through a show at Northeastern Illinois University and at outdoor art fairs, proved to be futile. But she summoned up the courage to take her work to commercial venues and was included in a couple of shows at women's alternative galleries. Also, a meeting with the Chicago dealer William Van Straaten resulted in his agreeing to represent her.[8] "He sold one of the early still lifes to Illinois Bell," Pasin Sloan recounts. "I thought, 'Goddamn, maybe I could really do this!' At the same time, I was embarrassed by it all. I thought the paintings showed that my life was ordinary, with no heroic content of any kind. I didn't realize until

later that that's *right*. You have to always work from your personal life and not reach for what you don't know."

In hindsight, Pasin Sloan has come to value her awkward beginnings as an artist. Primarily self-taught, she now claims "that was a blessing in some ways. If I'd gone to an art school with a stronger studio program, I might have not had the self-confidence to resist whatever the agenda may have been there. Also, I might have felt that I should do what other artists in New York were doing."

A series of works Pasin Sloan produced in the mid-1970s (discussed in detail below) feature an oddly felicitous arrangement of a chrome coffeepot, a plastic Heller coffee mug, a bit of blue pitcher, and a window with a fragment of curtain on top. These images foreshadow the artist's mature work in that the centrally placed coffeepot mirrors its immediate surroundings. "Even then," she says, "I was trying to pick objects that I thought exemplified their time, the twentieth century, due to their simplicity and boldness."

At an early stage in her career, Pasin Sloan took a stand against certain conventions of

Jeanette Pasin Sloan at home, River Forest, Illinois, 1995

still life—"Dutch *pronk*," she calls it. Her work has avoided the social or religious symbolism that helped form the genre. "It's amazing how in traditional still life, every little thing had some significance, usually religious, that the artist wanted to convey."

Pasin Sloan also has sought to avoid the sentimentality she sees in many still-life works, particularly those depicting flowers. "I never turned to nature," she says, because it "didn't have the formal qualities that interested me." Nor did the jugs and bowls and tablecloths of more conservative still life. "Certain objects convey a set emotion, an object or a piece of fabric that's reminiscent of something else. I never wanted that, and I've tried to avoid it."

A s she began making artistic headway, Jeanette Pasin Sloan grew determined to have her work exhibited in museums and other cultural spaces. When traveling, she would arrange to meet prints and drawings curators at various museums. One such stop at the National Museum of American Art in Washington, D.C., led that institution to purchase a work from her Farberware series. "It was just a small amount of money, but it meant so much to me!"

The colored-pencil *Farberware Coffee Pot No. VI* (1977, page 44) represented a significant moment in the artist's career. Near the center of the canvas is a stainless steel percolator that reflects objects around it on a countertop. Immediately to the left is a red Heller mug; behind it lies the coffeepot cord, casually tied. Part of a turquoise-blue ceramic pitcher is visible at the left-hand edge. There's a swatch of kitchen-window curtain in red, green, and beige at the upper left; a length of chrome above the counter repeats colors from around the arrangement; and three small, emerald-green pitchers are lined up on the right side of the window ledge.

Although *Farberware Coffee Pot No. VI* lacks the elegant formal brio characteristic of Pasin Sloan's later work, it does illustrate her embrace of the domestic milieu. To execute this piece, she employed colored pencils in order to achieve a kind of contouring that was not possible with acrylic paint, which dries rapidly. "I used colored pencils very much like paint, in that I layered them," she says. "It was horrendously laborious, although a lot of my shows in the late seventies at Gil's were made up of works done in colored pencil alone, or acrylic with colored pencil."[9]

"Gil" was G. W. Einstein, the New York City dealer who took the artist on in 1977 (and

with whom she showed until 1985) after William Van Straaten suggested that she find representation in Manhattan. Einstein found that small colored-pencil drawings were easy for him to "move" as he traveled to museums around the country. At the time, Pasin Sloan's technique with the medium was distinctive; when she completed a drawing, the paper was saturated with color, then buffed to a high sheen with Q-Tips.

The same year—1977—that Pasin Sloan drew *Farberware Coffee Pot No. VI*, she also painted the acrylic-on-linen *Bassano Pitchers* (page 41), notable for its sleek sophistication and casual sheen. A silver pitcher, placed just behind two gold-hued Bassanos, dominates the image. The gray ground includes a window that reflects a view of mountains in Italy. By this time, Pasin Sloan had learned how to use glazes with acrylic, in order to give her work light-to-dark contour and chiaroscuro. The painting—forty by forty inches—is one of her early triumphs; it has a technical finish, even a luster, that reveals the artist's natural gifts and her confident grasp of the rudiments, and the expressive potentialities, of representation.

In another work from 1977, *Silver Bowl and Pitcher with Red and Blue Stripes* (page 42), Pasin Sloan included fabric in the arrangement of objects, just as she had in the earlier *Toaster*. A stainless steel pitcher (the same one used in *Bassano Pitchers*) and a Revere Ware bowl rest on a length of cloth, silky in texture and patterned with muted scarlet and blue stripes. The cloth is bunched high up on both the right and left sides, helping to bracket the image. The silver pitcher reflects both the cloth beneath it and a convex view of the artist's studio. "The fabric brought in more formal intrigue," Pasin Sloan explains. Asked why the bowl portion of the Revere Ware piece is nearly obscured by the fabric reflections, she responds, "It created a whole new dimension of abstraction, of things going on within the object. Eventually, I came to think of my paintings as being *about* what goes on within the outline." The distorted quality of the reflection, she felt, created a tension between the real and the abstract.

Before long, fabric would come to dominate both the foreground and background of her images. For instance, in the acrylic-and-colored-pencil work *Colorful Reflections* (page 47), also from 1977, two Revere Ware bowls and a blue Heller mug are surrounded—and nearly overwhelmed—by a loose draping of brightly striped Marimekko fabric. "The fabrics became another object," says Pasin Sloan. "I used them to create space and movement where I needed it, and color."

A painting from 1979, *Black Bowl, Red Cup* (page 56), posed an interesting technical challenge. Black-and-gold-striped fabric lies on a table next to a rich, gold-and-black paisley bro-

cade; a silver bowl is almost enveloped by the brocade and by a mauve fabric lying over it. A red Heller mug is the most delineated of all the objects. "I started by gessoing a canvas black," Pasin Sloan relates, "then worked the lights into it. The light emerges in an unusual way, one that reminds me of how light resonates in those Mexican paintings on black velvet."

An increasingly sure, yet subtle, compositional sense emerged in Pasin Sloan's work of the late 1970s. It confirmed her ability to make beauty of common objects, and to arrange those objects in ways that suggest a formal ideal.

"I think my compositional sense may be innate," says Pasin Sloan. "It's a hard thing to teach, and it's a hard thing to compensate for. But it's the basis of everything. If you don't have that, ultimately nothing will work. Metaphorically, if there is order in a work of mine, it comes from the way the piece holds together compositionally. That says something to me about a belief in a possibility of that kind of order. It demands a certain belief and a hope."

When Jeanette Pasin Sloan speaks of "hope," she is perhaps referring to her view of skill, or technical facility, as a metaphor for man's attempt to master the difficulties of life. Her own particular figurative skills were honed late at night, at a kitchen table in a house in suburban Chicago, during a two-year period. The experience left her with an acute awareness of the plastic *and* the spiritual values inherent in our European art heritage: skill is, and always has been, what the poet Wallace Stevens called the "necessary angel" of artistic perception, or, specifically, artistic vision.

"I've always wondered," muses Pasin Sloan, "why I've held on to the need to do elaborate, skill-intensive paintings. It's *hard*, and a lot of it is boring. But probably for me psychologically—this may be part of my saint complex—it seems that unless you're suffering, you're not going to get to anything. Also, when you see certain things that human beings do that require extraordinary skill, it brings a certain feeling of hope."

She takes figure skating as a case in point. "Part of its power is the feeling that these athletes are doing something you couldn't do, because you have a sense of how much skill has to be acquired in order to get there. Even though at a certain point the event becomes magical—more than pure skill—without the skill, it wouldn't have the magic."

Another key to her technical skill is a thorough familiarity with her subject matter. She says that the imagistic quality of her work derives in part from her use of "the same objects over and over again. I have the objects in my head, so I can use them the same way as Philip Pearlstein uses figures—not so much a matter of content as a way to compose."

To achieve the starkly formal beauty of her acrylic still lifes, Pasin Sloan spends considerable time and effort "filling in the formal and coloristic information. A painting takes me two to four weeks, and half of the time is spent just doing that."

Setting up the still life is a major part of her creative process. The omnipresent Revere Ware pieces were actually given to the artist and her husband as wedding presents. Among the earliest items she purchased for the still lifes were the Heller mugs. "Sometimes, I select an object for its color," she says. "Or I'll find a fabric I want to use and choose objects that will work with it." She surrounds herself with a number of objects in the studio, then starts "fiddling until I get an arrangement that holds together."

Next comes a step integral to the process: "I photograph the setup in order to make 35mm slides. I have a camera on a tripod with a macro lens, so I can get up really close." Pasin Sloan takes up to fifty slides of the objects she wants to use, striving for utter clarity in each image. Then she looks at the slides through a linen-tester, a kind of magnifying glass, so she can decide which parts to include in the painting. "I do a lot of cropping with tape right on the slide," she explains. Next, she makes a drawing to scale on paper for a watercolor, or on canvas for an oil painting.

"In the beginning, I used acrylic paint," says Pasin Sloan about her choice of media. "I didn't know how to use anything else, and it just seemed easier to clean up when I was working in the kitchen. But there's a limited amount of blending you can do with acrylic. So for the underpainting, instead of putting in a few vague colors, as many painters do, I put all the information in—fairly opaquely—in a medium range of value. Everything's there before I glaze the painting, except that the colors are not brought up or down exactly the way I want them. In that first pass, the color usually is pretty much as I see it on the slide." To begin glazing, she puts more water in the acrylics (and later, with oils, puts more medium into the paint). Then she glazes every section of the piece according to her purely instinctive coloristic specifications. Next, she adjusts the color by layering the glaze to add tonal subtleties to the work.

Watercolor is another medium in which the artist is proficient. In the 1980s, she ordered from a catalog some silvery disposable party cups and began painting a series of twenty-

two-by-thirty-inch watercolors featuring these objects (pages 88–89). She cites this as a challenge from which she gained a great deal. "When you learn a new medium," she explains, "you gain something you can bring to the rest of your work."

In the 1990s, when Pasin Sloan began portraying the human figure (especially her own), she found that watercolor, in which she was then working, was insufficient. "I wanted a medium with more body," she recalls, "so I used gouache with watercolor glazes on top to bring up the color. I've always been willing to try a new medium, such as oils, which I began using when the acrylics started to look plastic and flat. It was a struggle, and it took a long time to get it right."

Yet whatever difficulties are involved in entering an unfamiliar medium, she believes, "you have to have a certain willingness to go with it—working within it and letting it feed you."

At the end of the 1970s, Pasin Sloan produced a group of works focused on the theme of white. The acrylic-and-colored-pencil work *White Still Life* (1979, page 54) is a fine example of this series. In it, two white Heller mugs—one lying on its side, the other upright—join a white pitcher in the background to form a circular motif around a Revere Ware bowl. These items are arranged against folds of a vertically striped fabric; the stripes—on a white ground—are red, black, white, and turquoise.

Also from this period, although not part of the white series, is *Still Life #93* (1980, page 58), which shows three shiny, silvery plastic goblets on a black-striped, aqua-hued fabric. Each cup reflects a view of the back of an apple that is positioned left of center in the foreground. Aside from the astonishingly smooth tonal blend of acrylic with colored pencil, *Still Life #93* is unusual because it contains one of Pasin Sloan's few representations of fruit.

In spite of her increasing competence as an artist—evidenced in part by her highly successful shows at G. W. Einstein's gallery and other venues in the late 1970s and early 1980s—Pasin Sloan continued to question the viability of her "domestic" subject matter and to seek a balance between her dual roles as painter and mother. Happily, she began associating with two other artists working in the Chicago area, Phyllis Bramson and Robert Lostutter. The trio began meeting for informal Friday-night dinners, during which they discussed their work and their lives beyond work. Of the three, Pasin Sloan was the only one who

was a parent. "This raised a lot of questions in my mind about combining motherhood with being an artist."[10] "It's very hard to do both," Pasin Sloan elaborates. "They both call for the same kind of focus and creative energy—total dedication to the task. And I wondered: If I were so serious an artist, why did I keep pulling away from it? Later, I came to understand that there is a kind of wisdom that comes from being a mother that can be of great value."

Pasin Sloan's fascination with an art of ideas, rather than an art of form and beauty, persisted. In the early 1980s, she adopted the term "heroic materialism" to describe her work and to "put a spin on it, a spin I thought it needed." She had first heard the term when it was used as the title of the final segment of Kenneth Clark's PBS series, *Civilisation*. In that context, it characterized the spirit behind turn-of-the-twentieth-century art and design produced at the behest of "robber barons" in New York. But she also thought the words aptly conveyed her response to the commercial art—or lack thereof—she observed during an extended family stay in Europe in 1982. She and her husband had taken the children out of school and spent just over half a year in Italy. They then took a car trip through Austria, Hungary, and Czechoslovakia.

"Hungary and Austria were fairly normal," she recounts, "but the Soviet influence was strong in Prague: there were tanks all over the place. And there were no consumer products to look at! If you went into a store, there'd be a row of canned tomatoes with the same drab label on them. Everything was generated by state factories. Cars were all the same color. If you went into a café, there'd be no signs for food or beer."

Driving back through Austria into Italy, Pasin Sloan found herself attracted to the billboards and advertisements along the way. "Here in America, we tend to see all of that as intruding on the landscape," she observes. "But when you don't have it, you find it shocking, even depressing." She thought about how much of what we see in America, in terms of color and design, relates to advertising.

The Pop artists of the late 1950s and 1960s had, of course, dealt with that material, making startlingly lifelike icons of the seemingly banal. But after visiting a country devoid of colorful, creative advertisements, Pasin Sloan decided that the scathing ironies of the Pop artists were misplaced. "I started to realize how interesting it all was," she says. "A lot of American creativity goes into advertising and product design. In Chicago, for example, there are several major ad agencies, and they deal with a great deal of innovative technology before artists do, especially today, in terms of the Internet and computers generally."

The notion of heroic materialism was reinforced when Pasin Sloan attended the opening of a new Neiman Marcus store in Chicago in about 1982. In the cosmetics department, she was overwhelmed by the beautifully designed and exquisitely displayed bottles of perfumes and body lotions. These artful arrangements, enhanced by quantities of orchids, made the artist feel like she was in a house of worship.[11]

"All of this finally inspired me to do a series of still lifes using consumer items—objects that showed the interests and tastes of the times," she says.

Images included, initially, a Sony portable radio, a Trak ski, a cup of Dannon yogurt, and even a Rubik's Cube, that popular brainteaser of the early 1980s (page 66).[12] Her most enduring works of this period are the acrylic-on-linen *Diet Rite* (1982, page 60) and the colored-pencil-on-rag-paper *7 Up* (1982, page 61). Unlike the ironic stance taken by Pop artists toward the consumer object, Pasin Sloan's approach is boldly forthright. Her aluminum Diet Rite can sits next to a "party cup" on a black-and-white-striped cloth, and her vivid green 7 Up can and plastic cup are similarly arranged against a length of garish fabric.

Not long after producing these two pieces, Pasin Sloan painted *Mercato Stripes* (1983, page 68). In this fifty-six-by-sixty-inch acrylic-on-linen image, the artist maintains the "heroic" spirit through the grandeur of scale, while de-emphasizing the "materialism." The lavish work suggests a sixteenth-century Venetian prince's well-laid feast table while at the same time acknowledging its peculiarly American, particularly gaudy origins. The artist now calls the low-content, high-design *Mercato Stripes* "a signature piece of that period."

When Jeanette Pasin Sloan finds a particular image to her liking, she enjoys re-creating it in various media—colored pencil and acrylic, for instance, or watercolor or oil. She is also partial to, and proficient at, printmaking. Her interest in this medium was initially encouraged in 1977 by her friend the painter John Himmelfarb, who suggested that she make a lithograph at Chicago's well-known Landfall Press. The result was a small work she entitled *Black Bowl* (page 37). At first, the process seemed alien to her; except for an intaglio class she had taken at the Art Institute, she was unfamiliar with lithography.

At that time, artists were still drawing on limestone, a cumbersome and expensive medium that has since been replaced by Mylar. (Unlike the stone, Mylar can be photo-

graphed onto aluminum plates, and it can be rephotographed if mistakes are made.) Pasin Sloan found that she loved working the limestone surface, in part because "you can grain it to a fineness or coarseness. The stone gets a superb 'tooth,' like paper. Whatever you put down is going to show up." Although she now thinks of *Black Bowl* as "kind of a clunky piece," producing it taught her "how to tackle the stone."

Dropping by Landfall Press one day in 1978 just "to say hello," she happened to have with her some colored-pencil drawings she was sending to G. W. Einstein in New York. The master printer Jack Lemon, owner of Landfall Press, looked at the drawings and indicated that he would like to publish one of Pasin Sloan's prints. At the time, she was working on the acrylic-and-colored-pencil drawing *Colorful Reflections* (page 47), in which she used boldly printed fabrics, and she showed Lemon slides of the setups. He very much liked what he saw; these slides served as the basis for a lithograph she would call *Silver Bowls* (1979, page 48). As it emerged, *Silver Bowls* was a big print—nearly thirty by forty-two inches. There was a black-and-white state, which, a critic noted, possessed a "fierce abstract quality,"[13] and, eventually, eight colors in the color edition.

Pasin Sloan worked at the press for three solid months. "Apart from showing my work in New York," she comments, "Landfall was the most significant thing that had happened to me as an artist. I was still very young, hadn't been around many artists, and here were Ed Paschke, Martha Mayer Erlebacher, Robert Arneson, and Laddie John Dill all hanging up their proofs. I was in direct contact with people who were very creative." In addition, she had the benefit of Lemon's considerable expertise. He taught her "how prints were put together, and a lot about color separation. He's a very quiet guy. He shows you things without saying a lot." At Landfall, the artist found, her abiding willingness to face the challenges involved in learning a new medium—and grow as a result—served her particularly well.

After working at Landfall for several years, Pasin Sloan produced prints through Chicago's Four Brothers Press, owned by the master printer Fred Gude, who had been trained at Landfall. These included *Bassano Stripes* (1984, page 76), notable for its iconic placement of a silver bowl against a crisp, brightly striped fabric.

Then, in 1986, Landfall Press proposed that Pasin Sloan create a boxed portfolio of four prints, different images but all on equally sized sheets. The portfolio would contain two lithographs, an etching, and a woodcut. She accepted, quite aware that the work would be arduous and time-consuming. But she also knew the project meant another chance to work with Jack Lemon, whom she highly respected.

The lithograph of the set that she did at Landfall is entitled *Sergeant First Class* (1986, page 85), a tongue-in-cheek reference to the yellow and black "military stripes" on either side of two long-stemmed silver champagne glasses, a silver matchbox, and a silver kettle. The second print in the set was a black-and-white state of *Sergeant First Class* (1986, page 83). In this print the drawing is clearly visible. "There's as much drawing in the color state, but the drawing isn't as apparent once more colors are added." Reflected in the kettle is a small, distorted self-portrait of Pasin Sloan as she snaps a photo of the setup.

The third print in the portfolio was an aquatint/etching entitled *Binary* (1986, page 82). It shows a silver bowl and cup placed against pinstriped ground. Surface reflections are minimal. In a sense, this piece is a kind of diagram schematization of the entire Pasin Sloan still-life oeuvre to date. "It was all done on one piece of copper," its creator explains. "And there were many gradations of gray. For every gradation, you do a stop-out with acid. It was complicated, figuring out how to do that much tonal variation on one plate." As it turned out, the plate, initially worked in New York City, had to be reworked at Indiana University in Bloomington by the master printer Rudy Pozzatti.

"One of the best I ever did" is how Pasin Sloan describes *Boston Red* (1986, page 84), the last print in the boxed set. It was executed in a manner akin to traditional Japanese *ukiyo-e,* using transparent, water-based inks. The final print required seventeen color separations, or woodblocks, and was worked in Boston under the supervision of Michael Berdan, who had studied with *ukiyo-e* masters in Japan.

Initially, Pasin Sloan had been stymied by this part of the portfolio project. "When Jack commissioned me, I said, 'I don't have a clue about how to do a woodcut.'" Lemon suggested that, in preparation, she execute a watercolor. "It made sense. Like woodcut printing, watercolor is transparent and water-based. It gave me a point of reference when I made the actual piece."

Still, there were challenges. "Lithography," says Pasin Sloan, "is very natural: you can create volume by going from lights to darks. But with a woodblock, there are only solids. To make something have contour requires a lot of blocks." She cut all the blocks herself.

In the resulting print a black demitasse cup is centered against two wide, bold black stripes on a white ground; behind it are a disposable party cup and a red Heller mug. The composition, simple and forthright, calls to mind the often hidden beauty of modern design.

Although by the late 1980s Jeanette Pasin Sloan was enjoying professional success, she realized that her marriage was faltering and would soon end. After nearly two decades together, she and James separated and subsequently were divorced.

"Nobody in my family had been divorced," she says. "I wasn't too religious, so the Catholic aspect didn't bother me. But I thought I'd lose everybody—my parents, my friends. I thought they'd be appalled. But everybody, including the kids, was supportive."

Liberated from a difficult marriage, Pasin Sloan found herself drawn to a subject that had long intrigued her, the role of *beauty* in art. "When I started talking about it," she recounts, "for example, in lectures I gave, it was like coming out of the closet even to admit you found beauty a useful thing. In the contemporary art world, beauty is seen as elitist. To make something beautiful confirms that you aren't concerned with social issues, that you're just interested in the appearance of things, not the content."

Pasin Sloan's notions about beauty are traditional, even conservative. But coming from a decidedly contemporary painter, one who emphasizes formal values in her work, her words carry a particular weight. She believes that we all want beauty around us; this desire is essential to being human. And of course, throughout the ages artists have used beauty to attract people to their work.

"But even though most artists don't aim for it anymore," she continues, "it's not going to go away. Art that isn't beautiful doesn't have much staying power." She points out, for

instance, that there is a significant difference between a Brueghelesque depiction of a slaughtered pig and Chris Ofili's *The Holy Virgin Mary* (1996), the cow-dung-festooned work that was included in the Brooklyn Museum's controversial 1999 exhibition *Sensation*. She contends that although the latter piece may have a philosophical point to make, because it has not undergone an essential transformation—"a movement toward order and beauty"—it falls short of being a real work of art.

Because of this strenuous de-emphasizing of beauty in the art world, Pasin Sloan feels, our time will be remembered less for its visual arts than for its film, photography, and scientific advances. "The space shuttle," she says, "is so much more visually powerful than painting. When I watch it take off, I almost weep. I can't remember a time since I grew up that I've gone into a contemporary art show and felt like crying, or laughing, or anything. Contemporary art doesn't touch you emotionally the way art should."

Pasin Sloan traces this state of affairs to the inception of modernism, with its acceptance in the late nineteenth century of the artist as an individual who stood apart from the herd and dictated his impressions to the rest of society. "He would have insights that nobody else had," she elaborates, "and *interpret* them for us. But in truth the artist translates the experiences we *all* have into art, showing and sharing with us what we're all thinking about."

For Pasin Sloan, the late 1980s and early 1990s proved to be a time of intense self-reflection. Over the course of five or six years, she saw her father and sister, Mary Ann, die, her marriage dissolve, and her two children leave home for colleges in the East. These life changes radically affected her work, which shifted from the formal to the psychological and from the stylized to the subjective.

The transformation first manifested itself in one of several large-scale watercolors she produced during that tumultuous period. In this particular work, untitled and painted in 1989, the artist depicted herself, nude, in a small-scale reflection on a silver decanter (page 90).

Pasin Sloan had of course always appeared in her setups—typically mirrored in the objects she was photographing—but she routinely eliminated herself before the pieces were finished. This time, however, she left herself in because "I thought it would *look* interesting."

In another watercolor from 1989, *Emergence* (page 91), the artist's disconsolate face, reflected in a large silver tray, dominates our view. She is nude to the waist, but all we can

see in the tray are her bare neck and shoulders. Part of her upper body is blocked by a stainless steel decanter and two silvery cups set against a black-and-white-striped fabric. "As I kept struggling with facing what was going on at that time," Pasin Sloan says, "the figure, in works such as *Emergence*, became larger and larger. These were the first really large watercolors I'd done. The medium was ideal for figurative work: it had a flow, spontaneity, and a fluidity.

"I thought about the nude self-portraits more consciously than the still lifes," she adds. "I saw myself as keeping some of the identity I had as an artist in my studio environment but also as embodying the question 'Where do I go from here?'"[14]

In 1991 she produced a work that can be considered the apogee of this period. *Untitled* (page 93), a medium-sized watercolor-and-gouache, shows the artist in a corner of her studio, with ceramic-lined silver bowls clustered in the lower left, a black-and-white picture of Eugene and Anna in the lower right, and, above the subject's right shoulder and breast, a framed trompe l'oeil wedding portrait. This striking painting works on several levels— past, present, and future—and in many ways reflects on itself and its creator.

The artist recalls that, when making this work and others in which she is unclothed, she thought a great deal about how much of her body to show: "I wanted these paintings to be somewhat generic since, without clothing, people are more generic. But I didn't want to be totally nude, because these weren't about sexuality. Instead, they were about how you identify the body in middle age and afterward. I began to see these works as dealing with a changing body. When I showed them at the Roger Ramsay Gallery in Chicago in 1992, people responded to that."[15]

Although viewers may have seen what Pasin Sloan was striving to convey in the self-portraits, these works did not sell as briskly as her other paintings had. Nonetheless, she takes enormous satisfaction in having faced down her demons both in the studio and in a public arena.

Perhaps the oddest—and most overtly symbolic, rather than naturalistic—of all the watercolors she produced during this self-reflective phase is *Half-Time* (1989, page 92). To the left, behind a silver cup and bowl, sits Pasin Sloan, staring questioningly, and challengingly, at the viewer. In the foreground and slightly to the right is a GE television on whose screen the artist and the bowl are reflected. The TV rests on two thick books: Arianna Huffington's 1988 biography *Picasso: Creator and Destroyer* and John Fowles's 1977 novel *Daniel Martin*. The artist explains that Picasso was an archetypal artist for her when she

was coming of age—"male and macho"—yet is quick to point out that as an artist she has long since departed from that model. Also, she admires the Fowles novel for the way it traces the personal growth of a creative person, focusing especially on how he learns to love.

The medium of television and its impact on contemporary communication intrigues, and occasionally appalls, Pasin Sloan. She observes that TV and, more recently, the computer have supplanted the theater's proscenium arch and movie screen as transmitters of information and entertainment. "Our common debates," she observes, "are today often voiced through the Oprah Winfrey show. It may seem stupid, but people watch it. Instead of sitting around with friends and neighbors, talking things over, we participate in these debates that go on behind a screen."

P asin Sloan's first show at the Tatistcheff Gallery in New York, in 1995, included some of her nude self-portraits. But it concentrated more on a new series of gouache-and-watercolors, watercolors, and oils that reflected another major change in her life—the purchase in 1991 of a home and studio in Santa Fe, New Mexico, where she now spends part of each year.

"I had to go through the self-portraits," she says, "but I was anxious to get back to still life." Pasin Sloan's hard-won peace of mind is evident in the work she began producing there in the early 1990s. In *Sun Dance* (1993, page 106), for example, a cup and saucer with a black-and-white kind of sunburst pattern is surrounded by three silvery mugs and a silver champagne glass. These objects are arranged against a fall of colorful fabric that evokes the Southwest. Even more than earlier work, *Sun Dance* seems to celebrate hue and form, inflection and reflection.[16]

The passing away of her sister in November 1990 shortly before the artist had moved to Santa Fe, stirred an awareness of death that inspired her to create two still lifes with a Christian theme. In one of them, *Chimayo Cruces* (1992, page 101), are a chalicelike plastic wine glass and a wooden cross with the kind of straw appliqué favored by Mexican and, later, New Mexican, craftsmen.

More typically, the mood of these still lifes is festive. "Some of them," says Pasin Sloan, "like *La Fonda* [1995, page 109], with its Navajo rug, include reflections of the mountainous

landscape near my house, seen from the deck. You're so aware of the light and the sky and the land there. It's very healing for me to go to New Mexico. It may be clichéd to say this, but the vastness of the landscape puts things in perspective."

Not all of Pasin Sloan's Santa Fe work is related to things Hispanic or Native American. Using a zebra-print fabric, she attempted to conjoin the realism of her paintings with their own intrinsic abstraction: *Pulsar I* and *Pulsar II* (both 1997, page 112) are the result. The two paintings are small gouache-and-watercolor studies for a larger painting, *Three Zebra Cups* (1997, pages 96–97); each has swirling decorative borders encasing two silver cups, which reflect the zebra stripe all around them. The larger work is also in gouache and has a transparent brown border that is, in its somberness, unusual for Pasin Sloan. Within the border is a lighter-brown rectangle containing the three cups. Zebra stripe runs every which way, through border and into reflecting images.

An addendum to the zebra series is *Octagonal Pitcher* (1997, page 98), which appeared in Pasin Sloan's second Tatistcheff Gallery exhibition, in 1997. "The zebra-stripe paintings were okay," the artist says, "and they were important for me to do. But I really wanted to see the realism and the abstraction working hand-in-hand." The outgrowth of this desire was a series, called Balancing Acts, that she began in Santa Fe. In one of the first works in the series, *Balancing Act II* (1997, page 115), a Revere Ware bowl is placed on a vase that has been laid on its side. In front of the vase are two cheap silvery cups, one upright, the other tipped over. Inside the bowl are another cup and an object that is difficult to identify. The arrangement is a gyrating, graceful jumble of the kinds of objects Pasin Sloan has customarily used. But here her trademark reflections are less noticeable than in previous work.

In *Balancing Act VI* (1998, page 118) the artist replaced her typical fabrics with simple paper grounds enhanced by strong light coming from colored gels that she had placed behind and underneath the objects. As a result, "the shadows and reflections in the background have become objects in themselves," she notes.

Pasin Sloan admits that she occasionally used tape to achieve these unusual setups, these improbable "balancing acts." She says that the feeling she is trying to evoke in these works is of being "centered in an unknowable environment. It's like Santa Fe: when you look at a starry sky, black with little dots, your place in all that is not settled. It's both disconcerting and freeing. It's really how we go through life—ultimately, toward that big void we can't escape."

As is evident in her art, Jeanette Pasin Sloan loves order and beauty and disparages the grunginess that characterizes so much contemporary work. Nonetheless, she emphatically defines her own paintings and prints as *modern.* And rightly so: her art could only have been made toward the end of the twentieth century. The subjects she depicts, from elegant Revere Ware bowls to everyday soda cans are thoroughly modern in their design.

Even more distinctively modern are the artist's wildly distorting and disturbing reflections in a silver eye—of her immediate surroundings, of her studio, of the sky, and even of herself—that she includes in nearly every work. Could the twentieth-century modernist Pasin Sloan thus have something in common with the sixteenth-century mannerist Parmigianino, whose "sitter" and background interior in his *Self-Portrait in a Convex Mirror* (1524) conform, voluptuously and oddly, to the visual dictates of a convex glass? As the art historian H. W. Janson puts it in describing that work, "The distortions . . . are objective, not arbitrary, for the picture records what Parmigianino saw as he gazed at his reflection in a convex mirror. . . . Parmigianino substitutes his painting for the mirror itself, even employing a specially prepared [circular] convex panel. *Did he perhaps want to demonstrate that there is no single 'correct' reality, that distortion is as natural as the normal appearance of things?*"[17] [italics mine]

Jeanette Pasin Sloan is a painter who has made still life the modern vehicle for the sort of vision Janson characterizes. This achievement, attained by means of a finely tuned technique and a rigorous pursuit of realistic beauty, ranks her among the exceptional artists of our day.

NOTES

1 Michelle Vishny, "Notes on Still-Life Painting and the Art of Jeanette Pasin Sloan," *Arts* 57, no. 7 (March 1983): 126.

2 For a brilliant overview of the development of still-life painting in the West, see H. W. Janson, *History of Art,* 4th ed., rev. and exp. Anthony F. Janson (New York: Harry N. Abrams, 1991).

3 Ibid., 579.

4 Ibid.

5 All remarks by the artist not otherwise attributed are from conversations with the author, August–December 1999.

6 The best essay on the artist is Marty Stewart Huff, "Jeanette Pasin Sloan: Picturing a Woman's Life," in *Jeanette Pasin Sloan*, exh. cat. (Milwaukee: University of Wisconsin, 1995).

7 Ibid., 3.

8 Ibid., 4.

9 Vishny, "Art of Jeanette Pasin Sloan," 128.

10 Huff, "Jeanette Pasin Sloan," 9.

11 For a slightly different angle on heroic materialism, see Huff, "Jeanette Pasin Sloan," 7–8.

12 These works are also treated in Vishny, "Art of Jeanette Pasin Sloan," 128.

13 Huff, "Jeanette Pasin Sloan," 9.

14 The definitive piece of writing on the nude self-portraits is Dennis Adrian, *Jeanette Pasin Sloan,* exh. cat. (Chicago: Roger Ramsay Gallery and Landfall Press, Inc., 1992).

15 For a review of this exhibition, see Henry Hanson, "Candid Canvases: One Woman's Life Story," *Chicago* 41, no. 12 (December 1992): 25.

16 For another assessment of the Santa Fe paintings, see Diane Armitage, "American Realism and Figurative Painting," *THE* 3, no. 1 (July 1994): 69.

17 Janson, *History of Art,* 514.

JEANETTE PASIN SLOAN

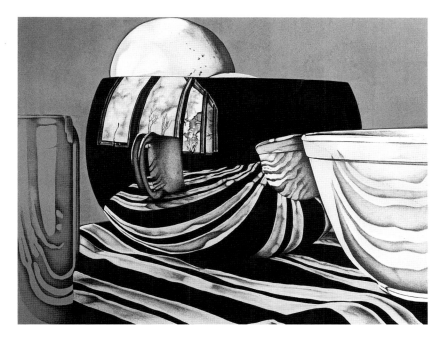

BLACK BOWL 1977, Lithograph, 24× 30 in.
Jeanette Pasin Sloan

T.V. 1974, Acrylic on Masonite, 40 × 50 in.
Jeanette Pasin Sloan

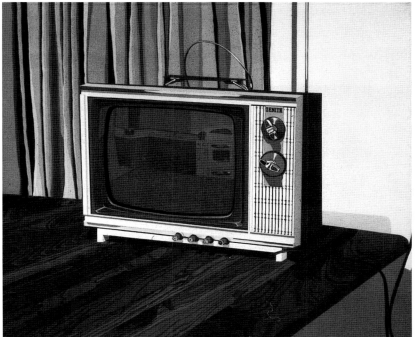

HIGH CHAIR 1973, Acrylic on Masonite, 60 × 45 in.
Jeanette Pasin Sloan

37

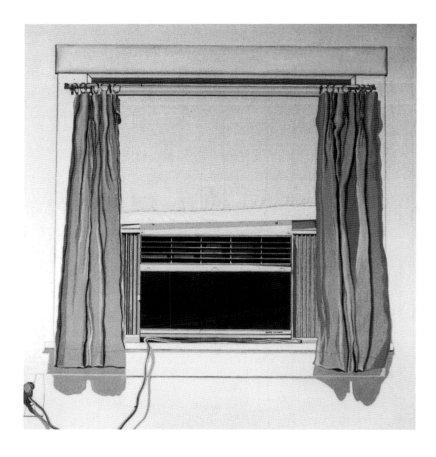

AIR CONDITIONER 1974, Acrylic on Masonite,
35 × 30 in.
Jeanette Pasin Sloan

TOASTER 1975, Colored pencils on rag board,
15 × 20 in.
Kathleen Maloney and Domineck Abel

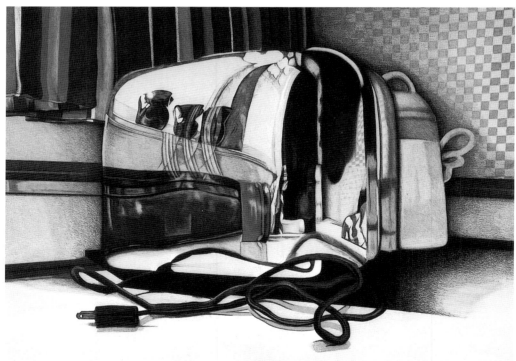

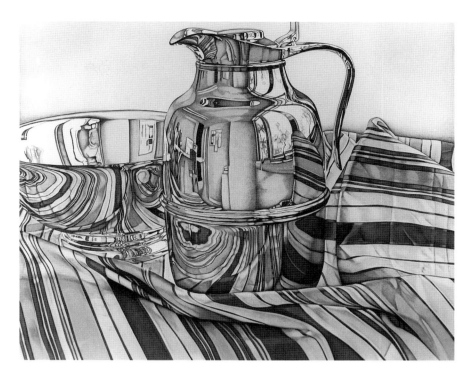

UNTITLED 1977, Colored pencils on rag board, 32 × 40 in.
Location unknown

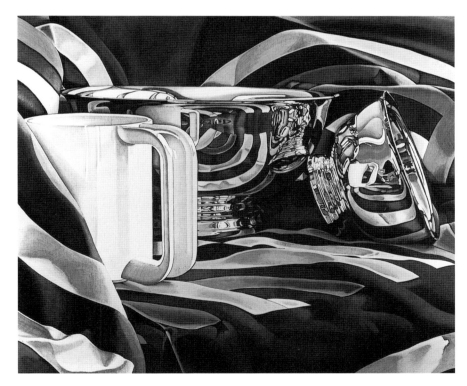

SILVER BOWL 1978, Acrylic on linen, 46 × 54 in.
Western Electric, Chicago

BASSANO PITCHERS 1977, Colored pencils on rag board, 30 × 40 in.
Cleveland Museum of Art

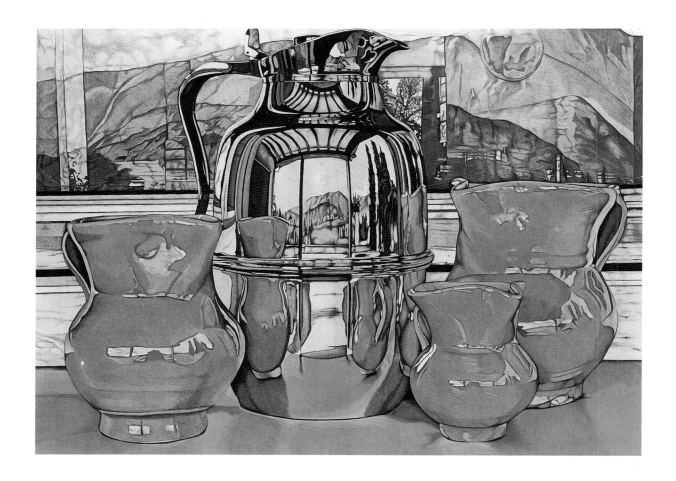

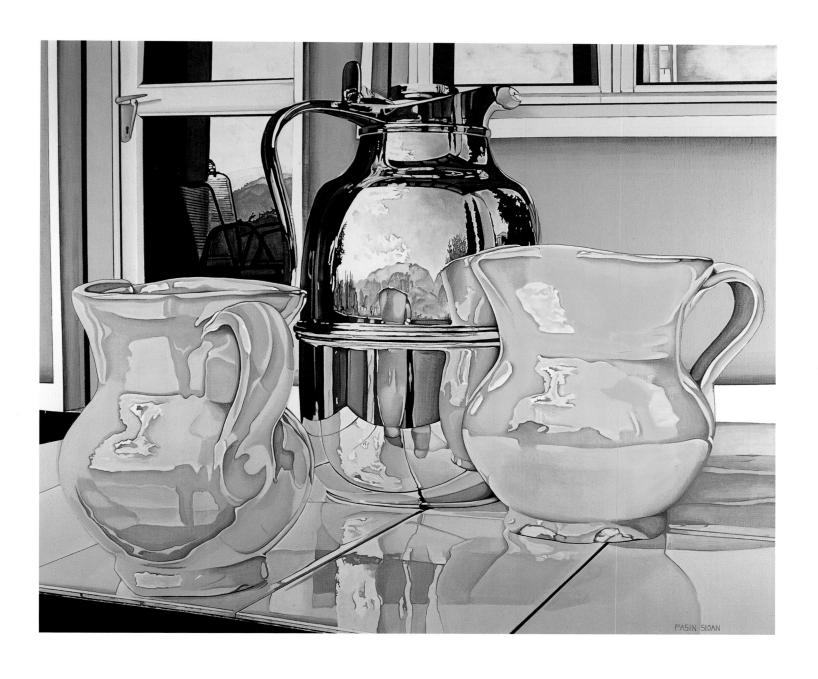

BASSANO PITCHERS 1977, Acrylic on linen, 40 × 48 in.
Private collection

SILVER BOWL AND PITCHER WITH RED AND BLUE STRIPES
1977, Colored pencils on rag board, 30 × 40 in.
Kathleen Maloney and Domineck Abel

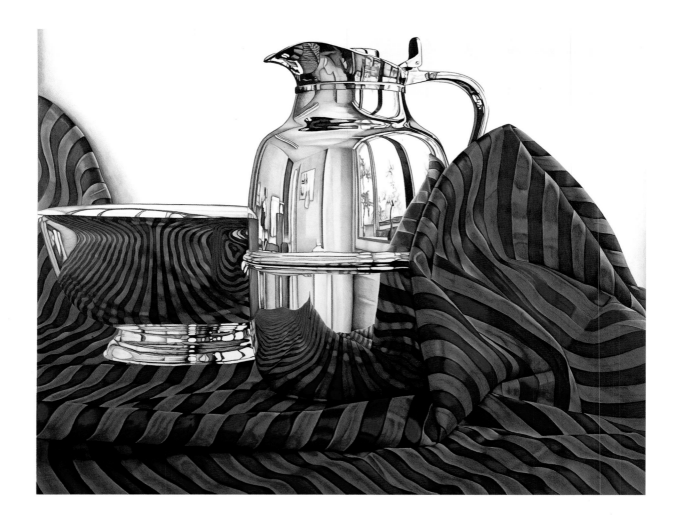

TWO BOWLS WITH STRIPES 1977, Acrylic and colored pencils on rag board, Diam.: 26 in.
Location unknown

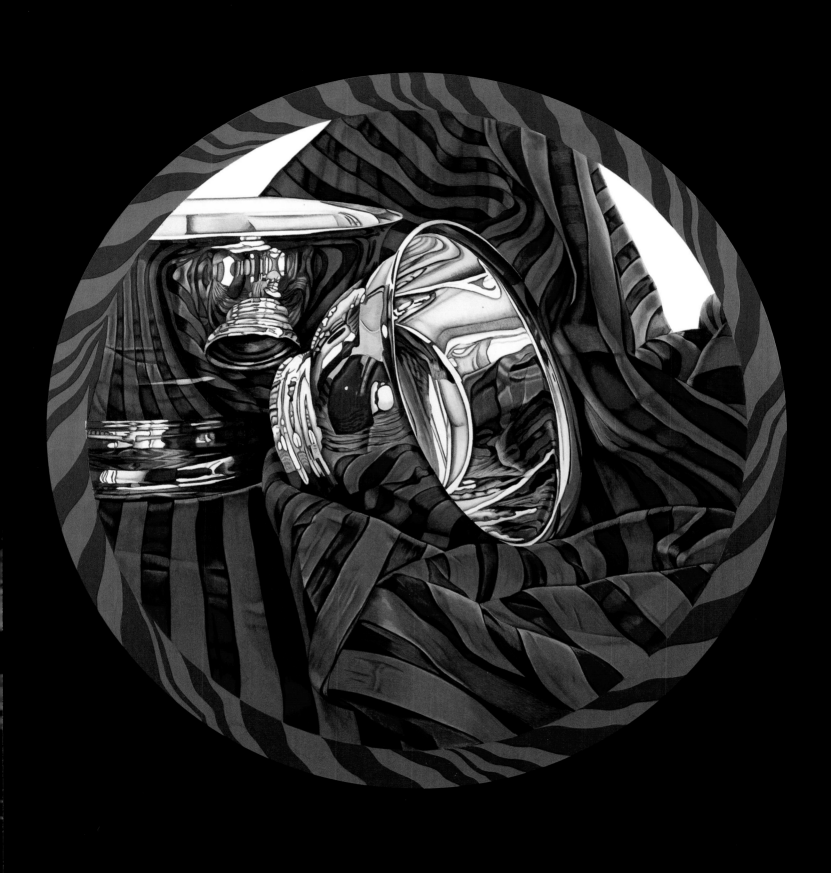

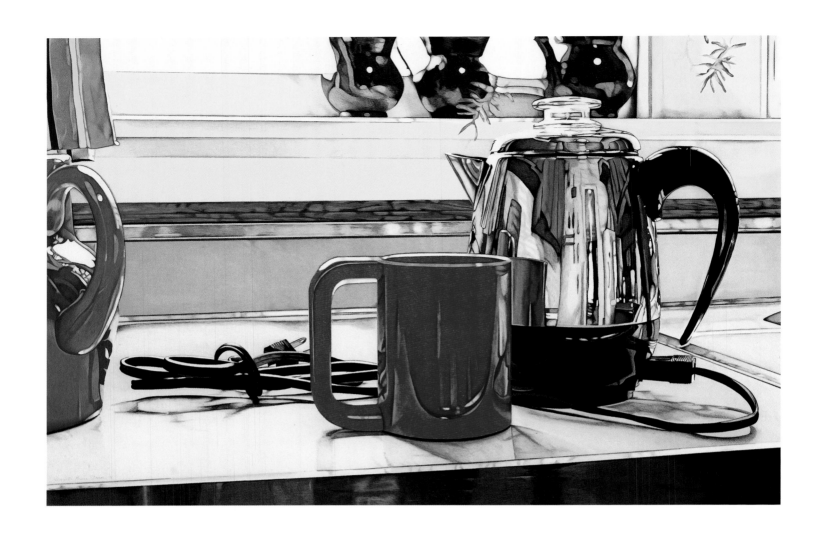

FARBERWARE COFFEE POT NO. VI 1977, Colored pencils on rag board, **22** × **30** in.
National Museum of American Art, Smithsonian Institution, Washington, D.C.

SILVER BOWL WITH WHITE CUP 1977, Acrylic and colored pencils on rag board, 31 × 42 in.
Canton Art Institute, Canton, Ohio

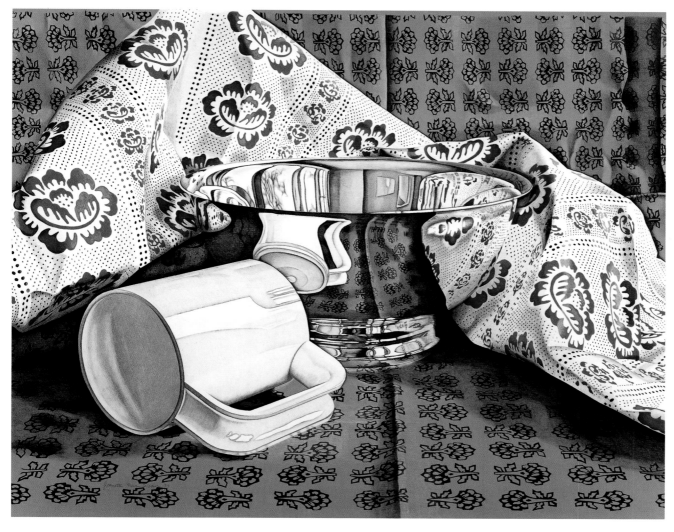

SILVER BOWL STILL LIFE 1978, Acrylic and colored pencils on rag board, 28½ × 38½ in.
Location unknown

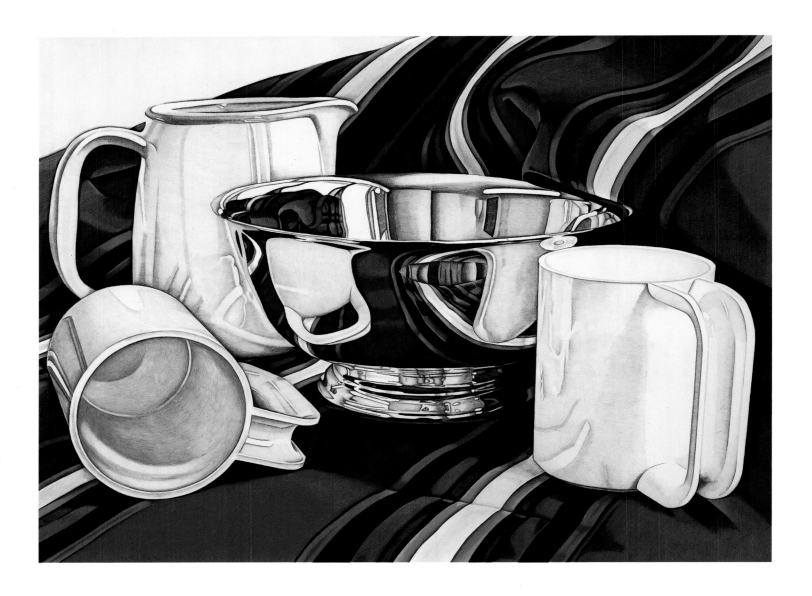

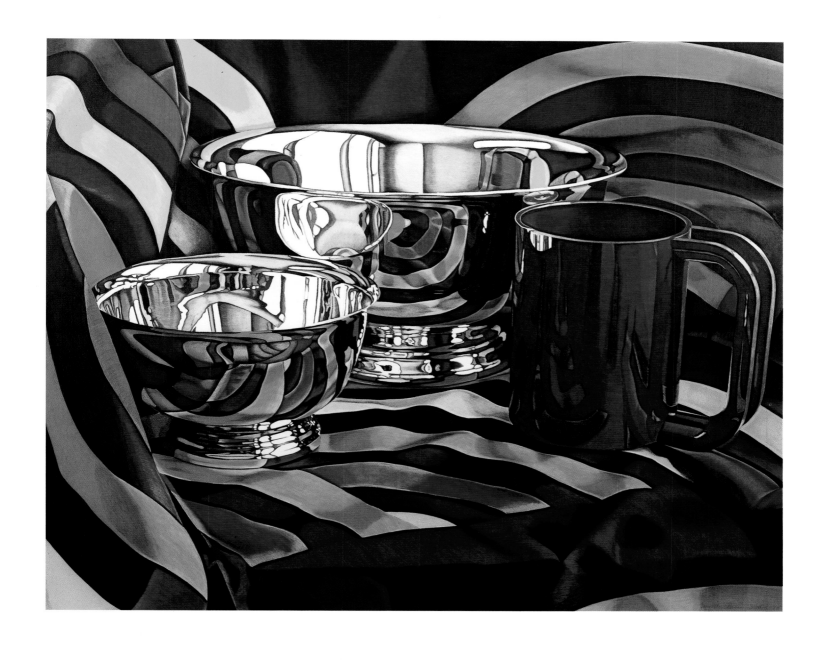

COLORFUL REFLECTIONS 1978, Acrylic and colored pencils on rag board, 28 × 38 in.
Location unknown

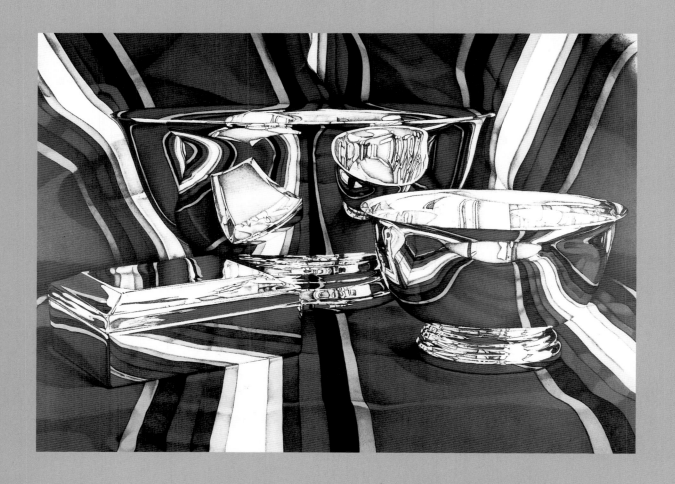

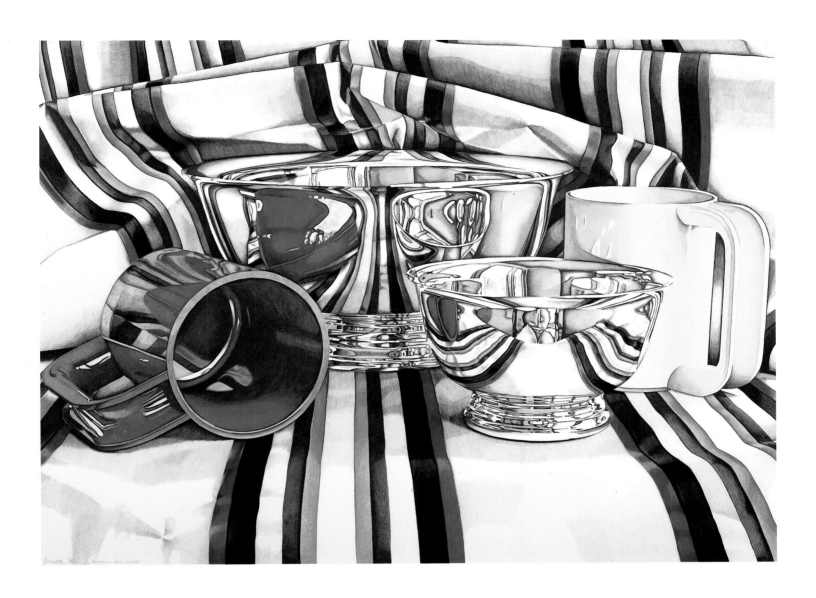

SILVER BOWLS, GREEN CUP, YELLOW CUP 1978, Colored pencils on rag board, 28 × 38½ in.
Patricia and Thomas Shannon

SILVER BOWLS 1979, Lithograph, 29¾ × 41¾ in.
Published by Landfall Press, Inc., Chicago (opposite)

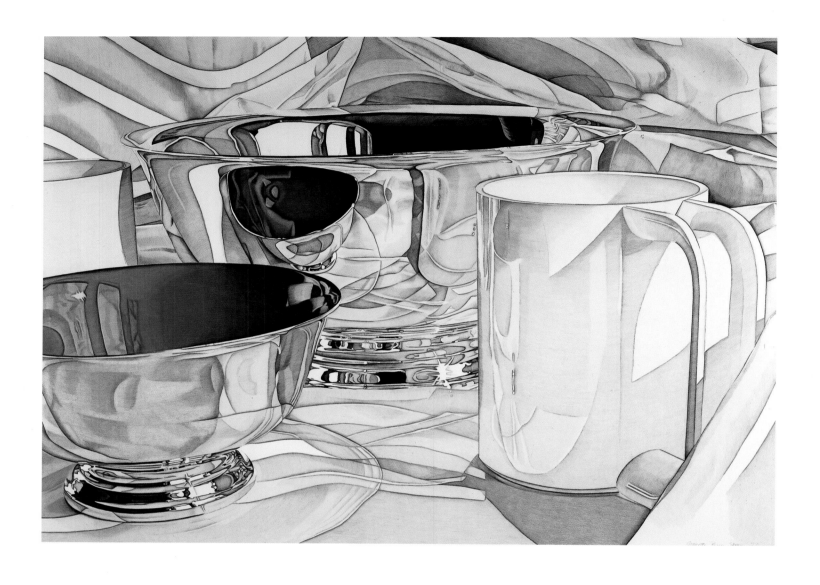

GLACIAL STILL LIFE 1979, Acrylic and colored pencils on rag board, 32 × 40 in.
Indianapolis Museum of Art, Indianapolis, Indiana

50

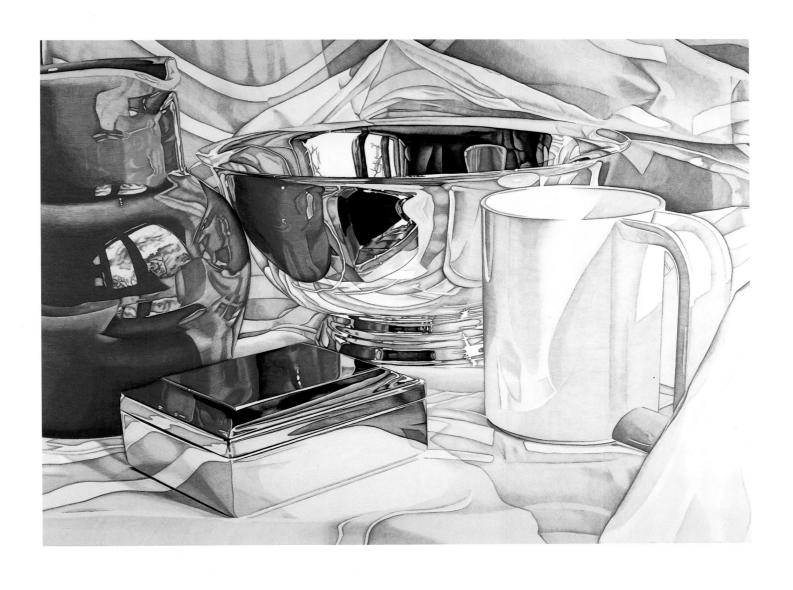

BLUE PITCHER 1979, Colored pencils on rag board, 32 × 40 in.
The Art Institute of Chicago

PITCHER WITH WHITE STRIPES 1979, Acrylic on linen, 58 × 78 in.
FMC Corporation, Chicago

PITCHER WITH WHITE STRIPES (detail, opposite)

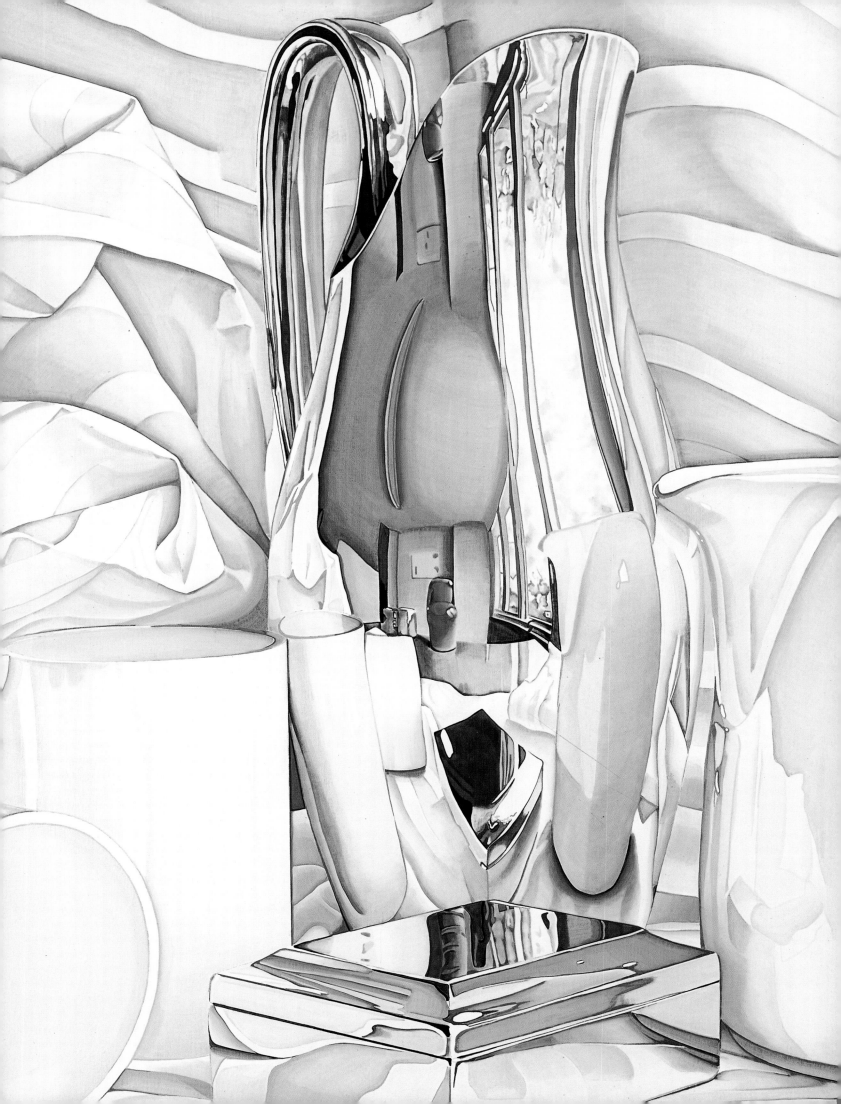

WHITE STILL LIFE 1979, Acrylic and colored pencils on rag board, 29¼ × 39½ in.
Ronald and Marilynn Grais

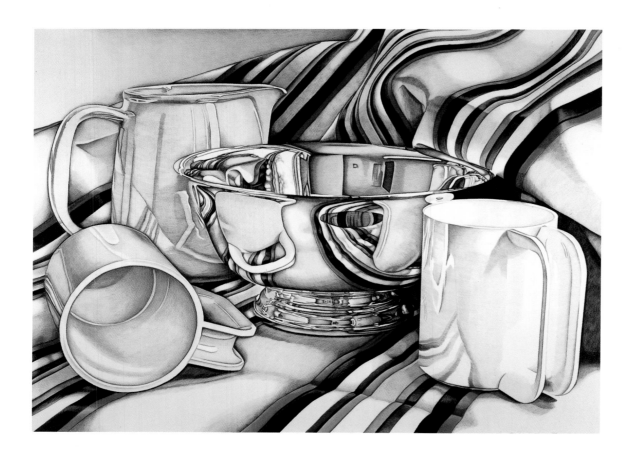

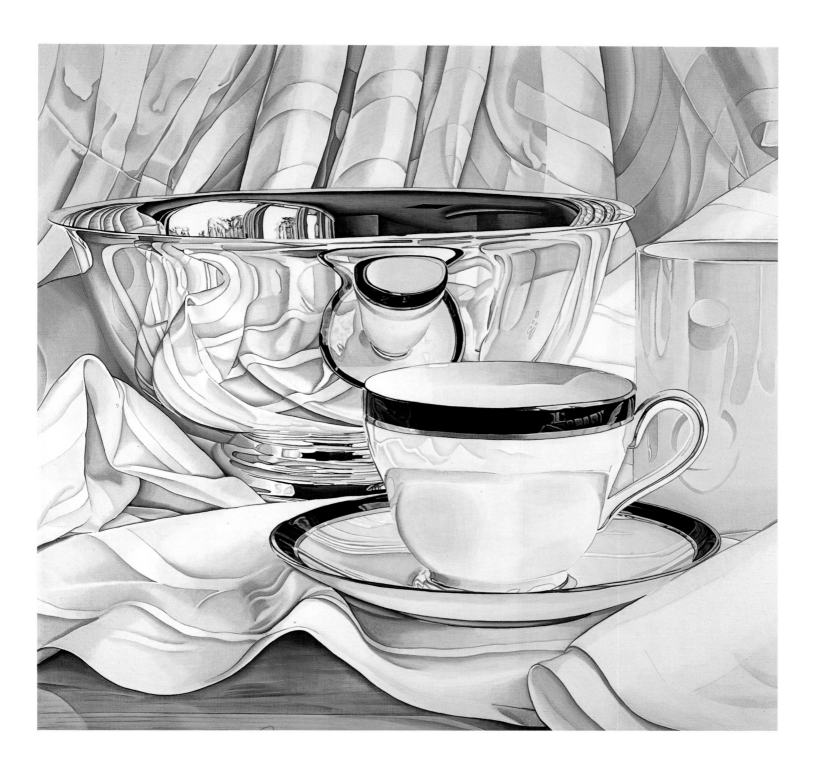

STILL LIFE #86 1979, Acrylic on linen, 36 × 38 in.
Private collection

BLACK BOWL, RED CUP 1979, Acrylic on linen, 48 × 64 in.

Peat, Marwick and Mitchell, Denver, Colorado

56

FOUR GLASSES WITH GOLD RIMS 1980, Colored pencils on rag board, 27½ × 39¼ in.
Marc Pachter

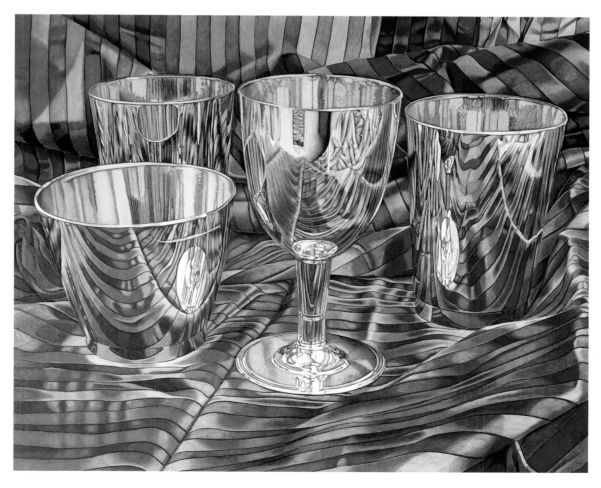

STILL LIFE #93 1980, Acrylic and colored pencils on rag board, 18½ × 24 in.
Private collection

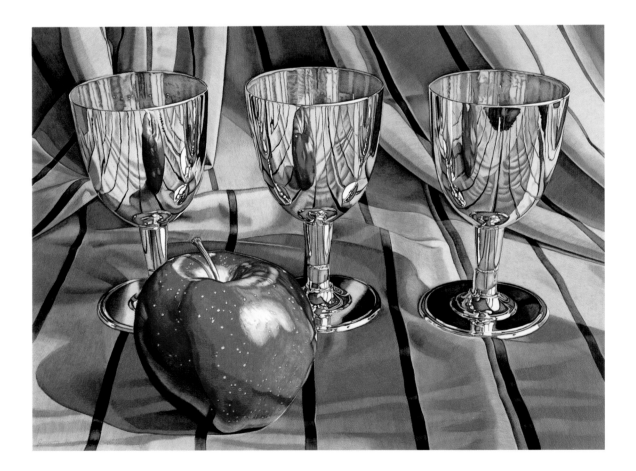

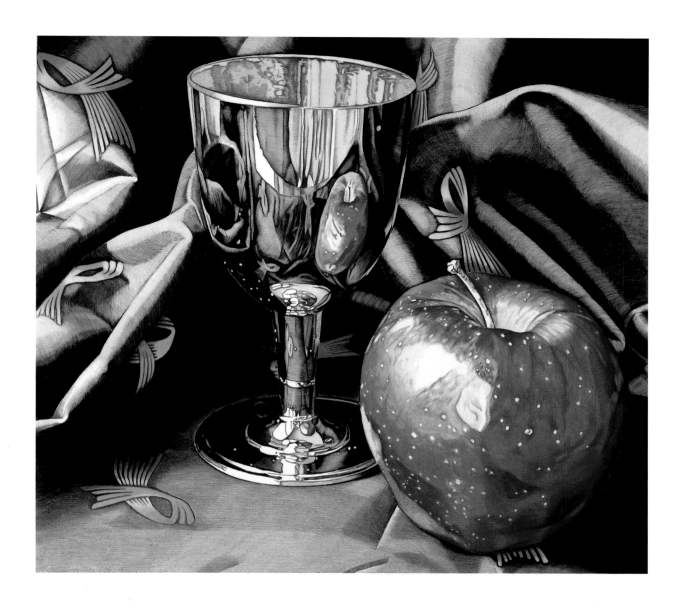

WINE GLASS AND RED APPLE 1980, Colored pencils on rag board, 16¼ × 17¾ in.
Minneapolis Institute of Arts

7 UP 1982, Colored pencils on rag paper, 37½ × 27½ in.
The Metropolitan Museum of Art, New York (opposite)

DIET RITE 1982, Acrylic on linen, 42 × 40 in.
A. M. Kailing and Associates

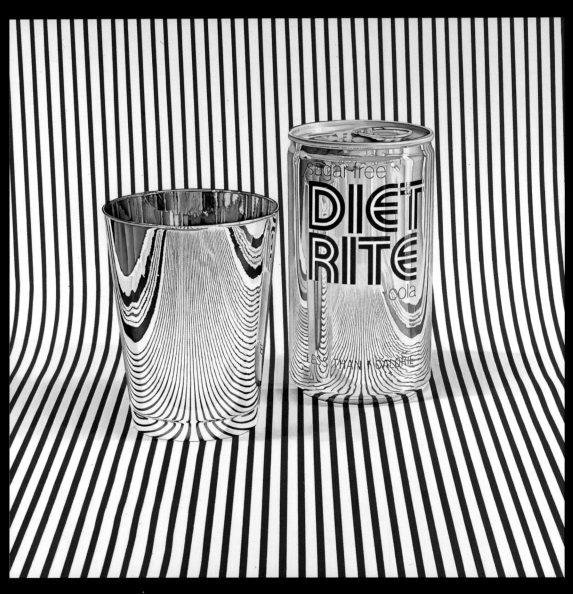

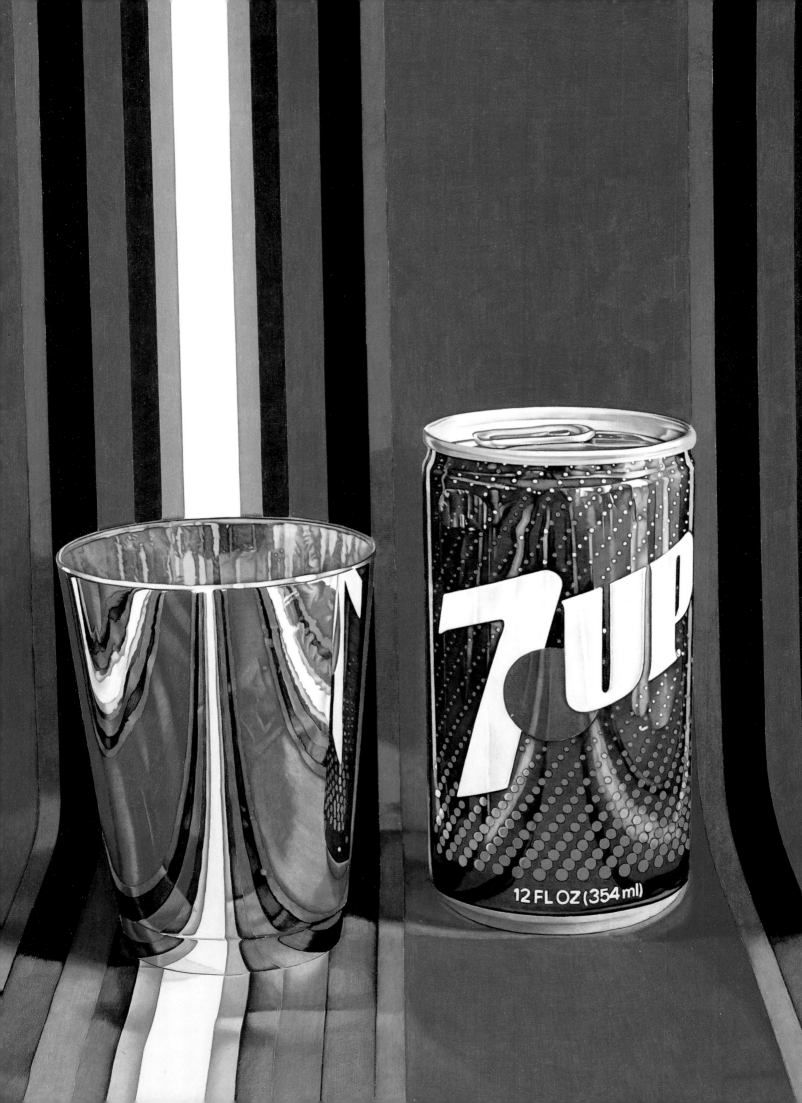

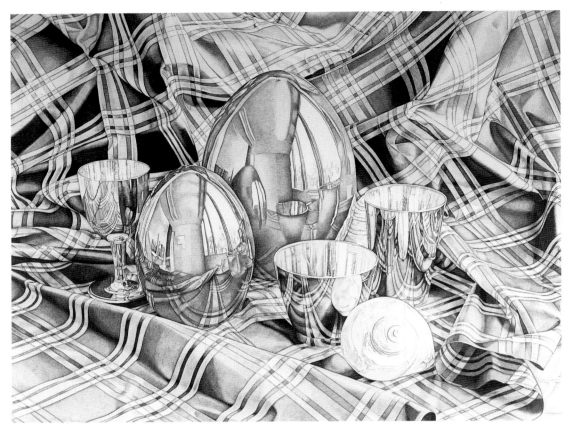

TWO CUPS WITH TWO REFLECTIVE EGGS
1981, Pencil on rag paper, 37¾ × 49⅜ in.
General Electric, Fairfield, Connecticut

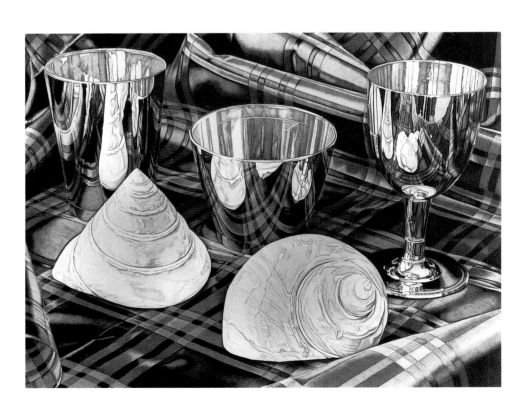

STILL LIFE WITH SHELL 1982,
Colored pencils on rag board, 24 × 28 in.
Mario A. Pasin

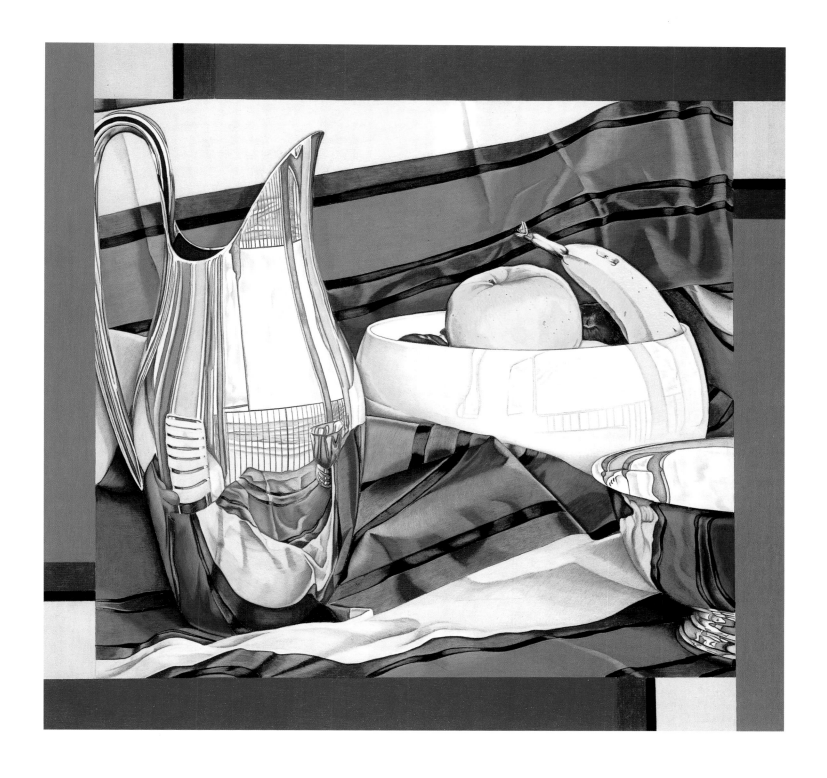

BOCA RATON PITCHER 1980, Acrylic and colored pencils on rag board, 25 × 26½ in.
Jalane and Richard Davidson Collection, The Art Institute of Chicago

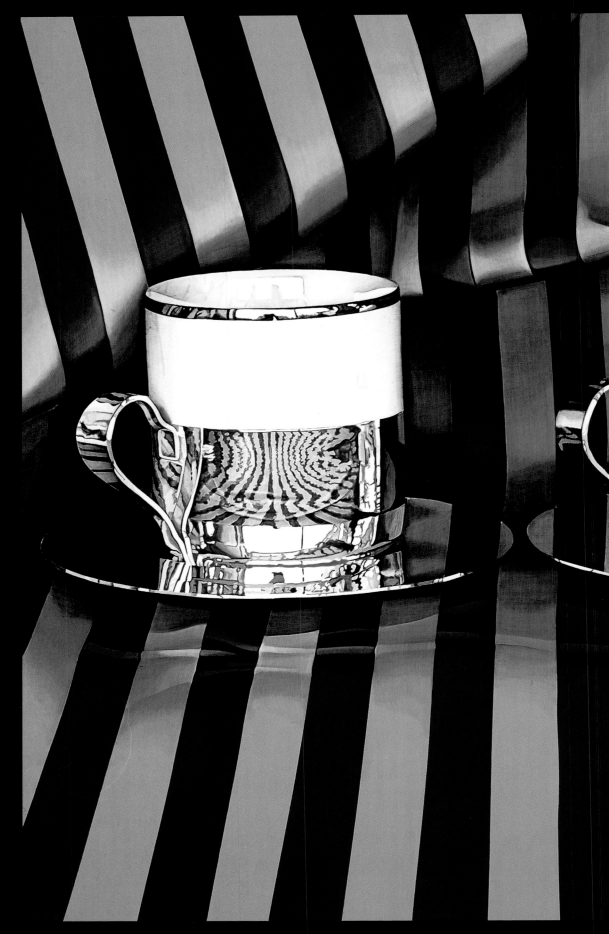

THREE ESPRESSO CUPS 1984,
Acrylic on linen, 38 × 60 in.
Captiva Corporation, Denver,
Colorado

64

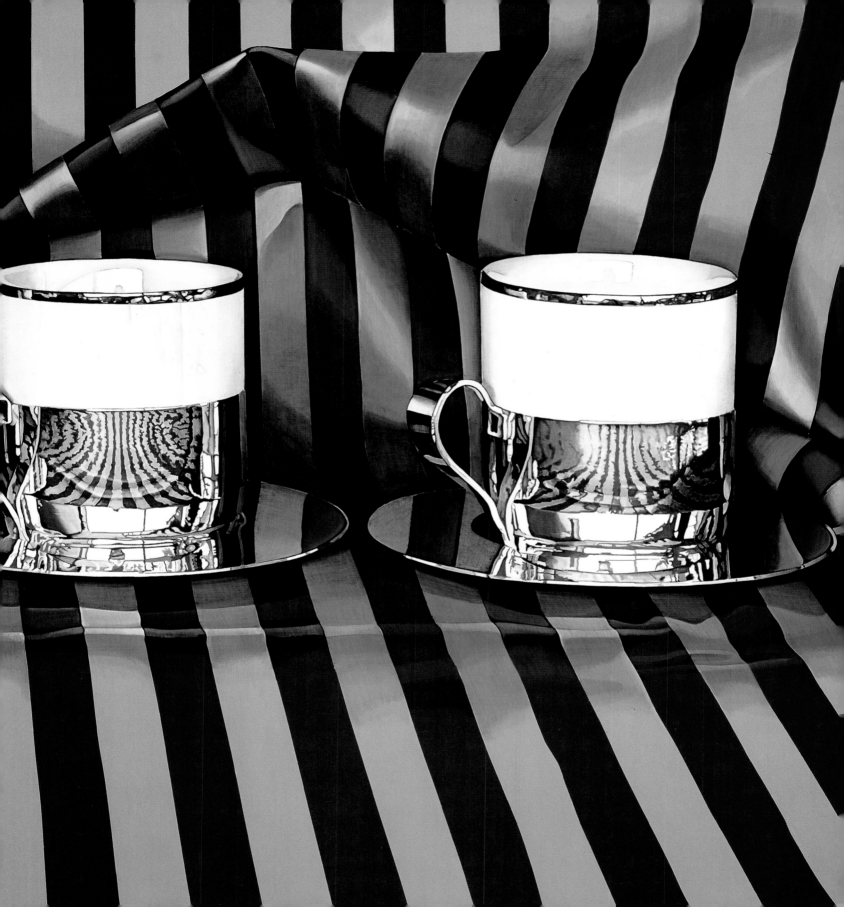

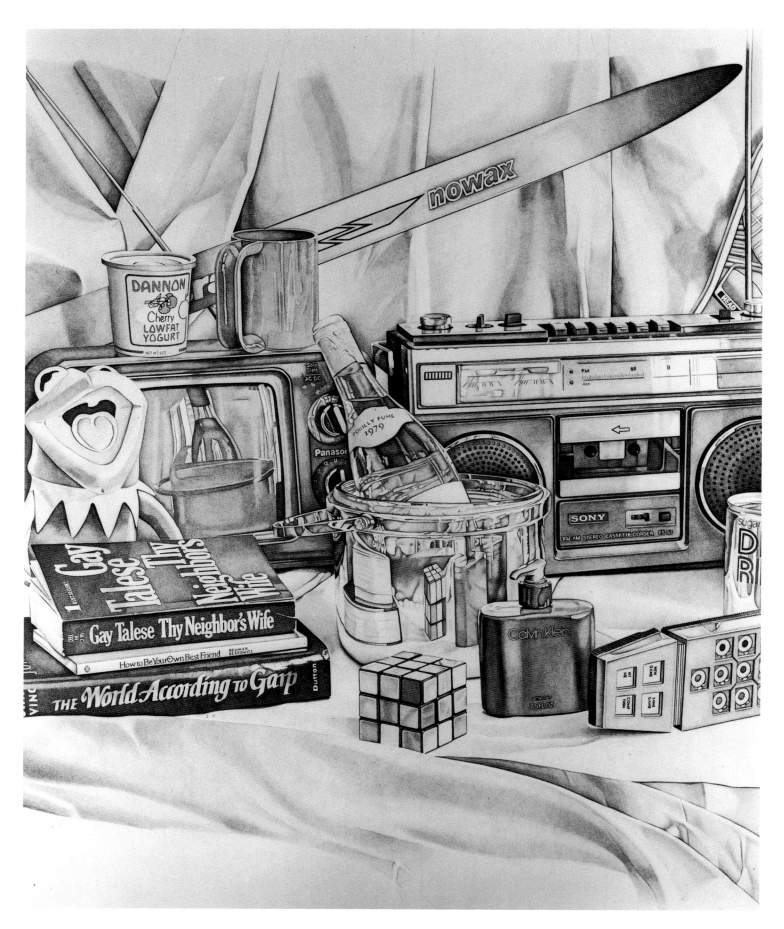

HEROIC MATERIALISM #2 1982, Pencil on rag paper, 62½ × 50½ in.
Drawing has been recomposed
Jeanette Pasin Sloan

UNTITLED 1983, Acrylic and colored
pencils on rag board, 16¼ × 14 in.
Private collection

MERCATO STRIPES 1983, Acrylic on linen, 56 × 60 in.
Snite Museum of Art, University of Notre Dame, Notre Dame, Indiana

STRIPES 1983, Acrylic on linen, 61 × 57 in.
Location unknown

MACCHI'S STILL LIFE 1984, Pencil on rag board, 28½ × 24½ in.
Arkansas Arts Center, Little Rock

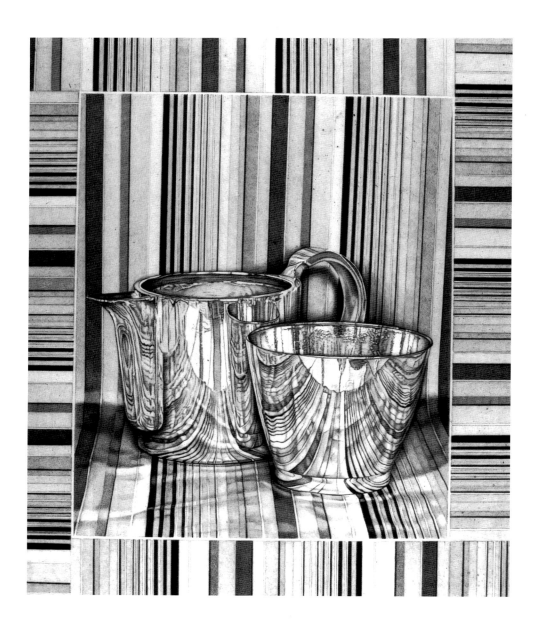

SEARS TOWER 1986,
Black-and-white state
lithograph, 50 × 31 in.
Published by John Szoke
Graphics Inc., New York

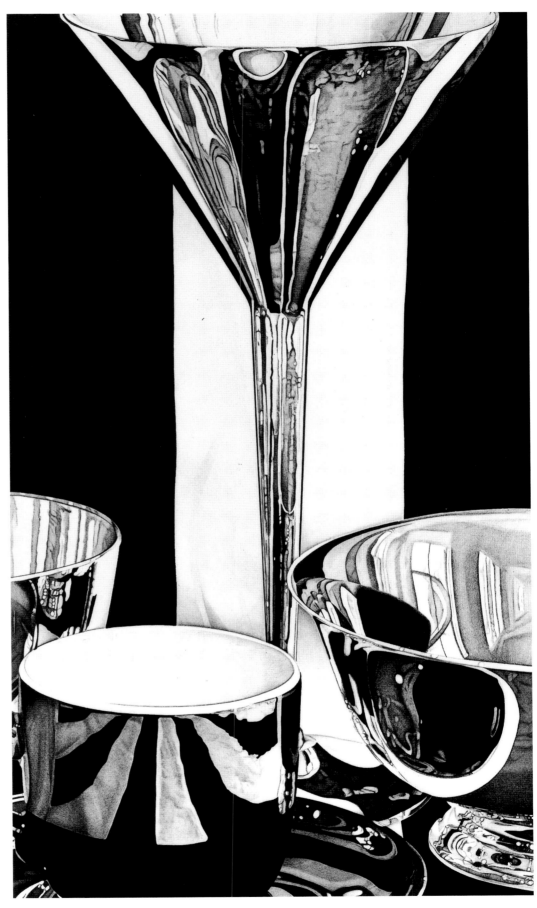

MACCHI'S STILL LIFE 1987, Oil on linen, 56 × 40 in.
Margaret Charlton

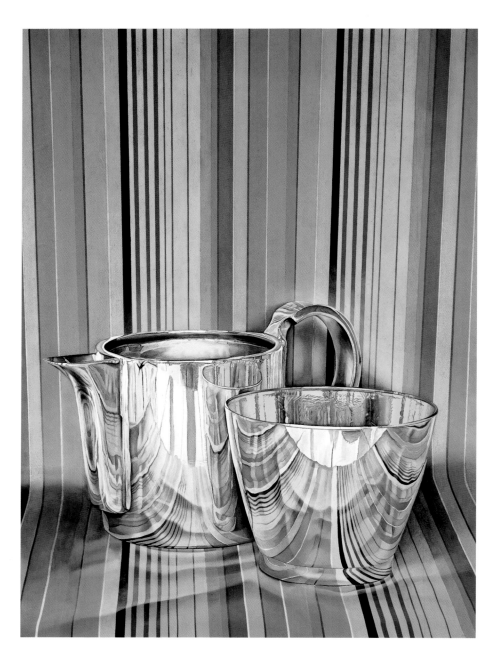

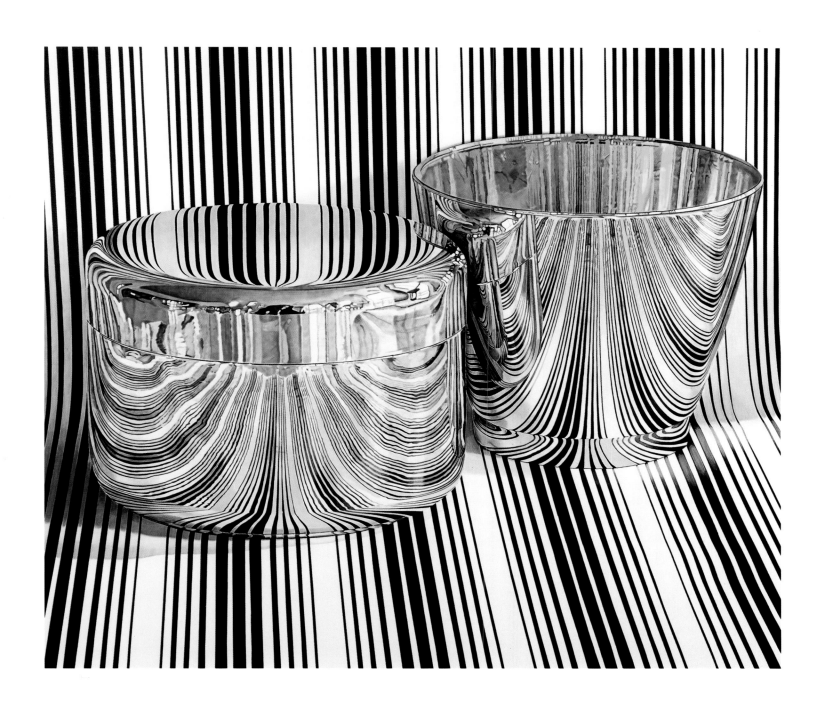

MARINA CITY 1985, Acrylic on linen, 50 × 56 in.
First Illinois Bank of Evanston

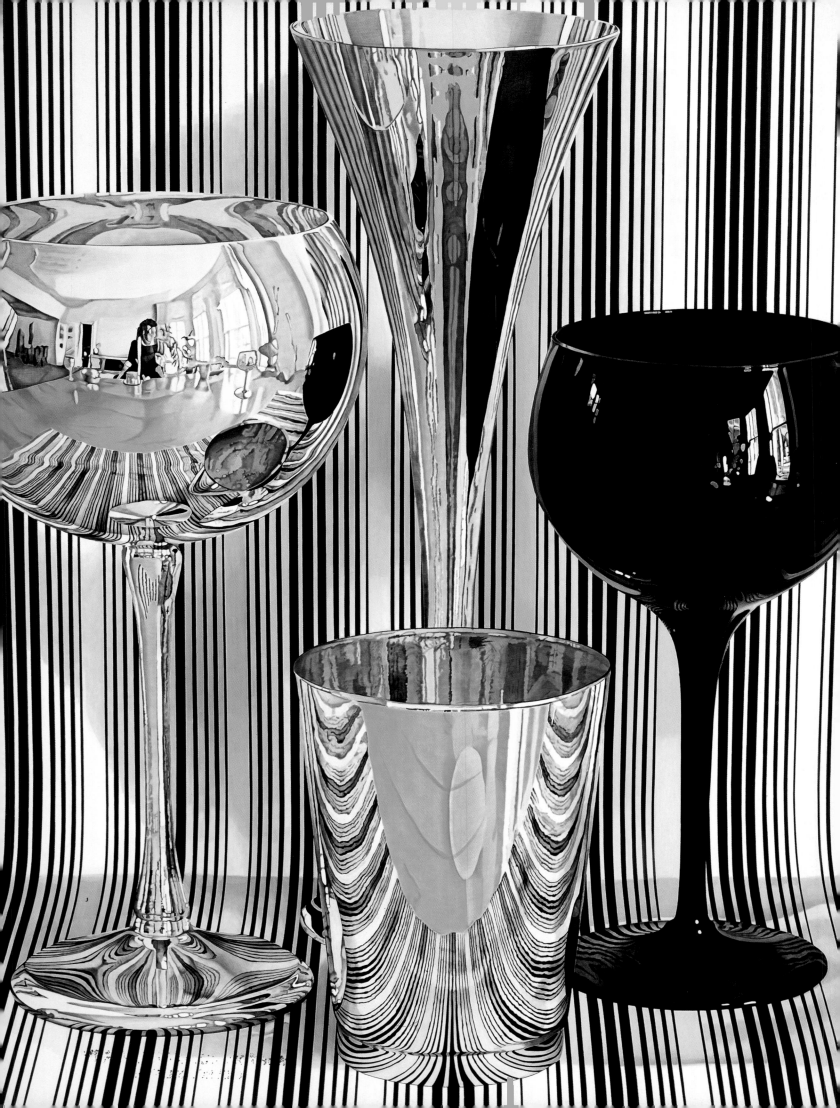

CHICAGO SKYLINE 1984, Acrylic on linen, 76 × 57 in.
Ortho-Tain, Inc. (opposite)

(detail below)

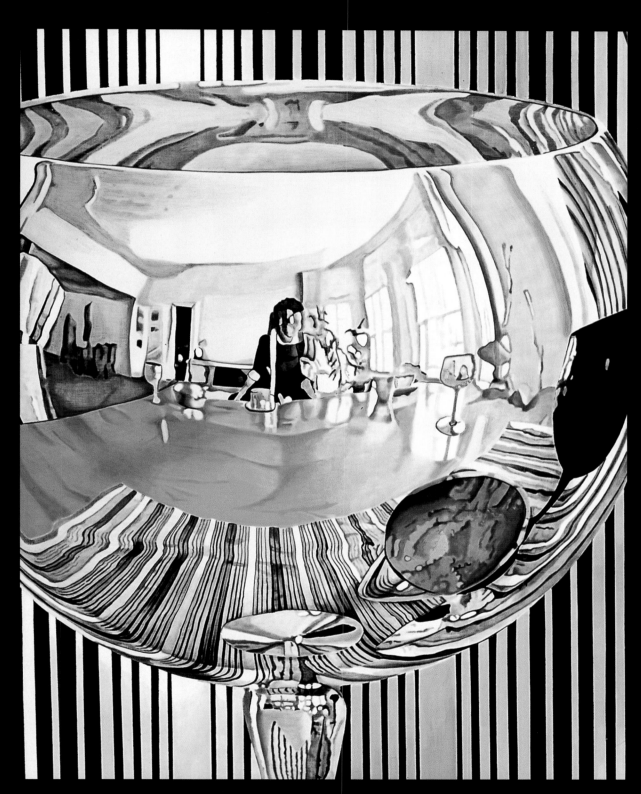

O'HARE RUNWAY #4 1985, Acrylic on linen, 72 × 56 in.
Private collection

BASSANO STRIPES 1984, Lithograph, 25 × 22½ in.
Published by Four Brothers Press, Chicago

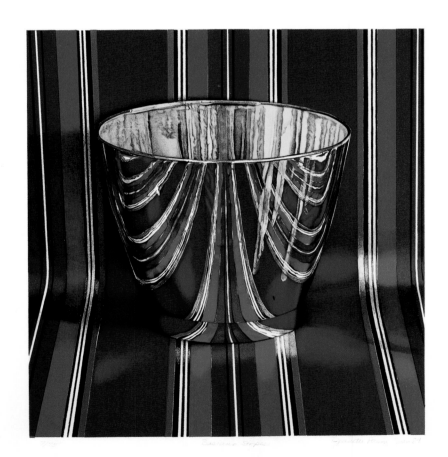

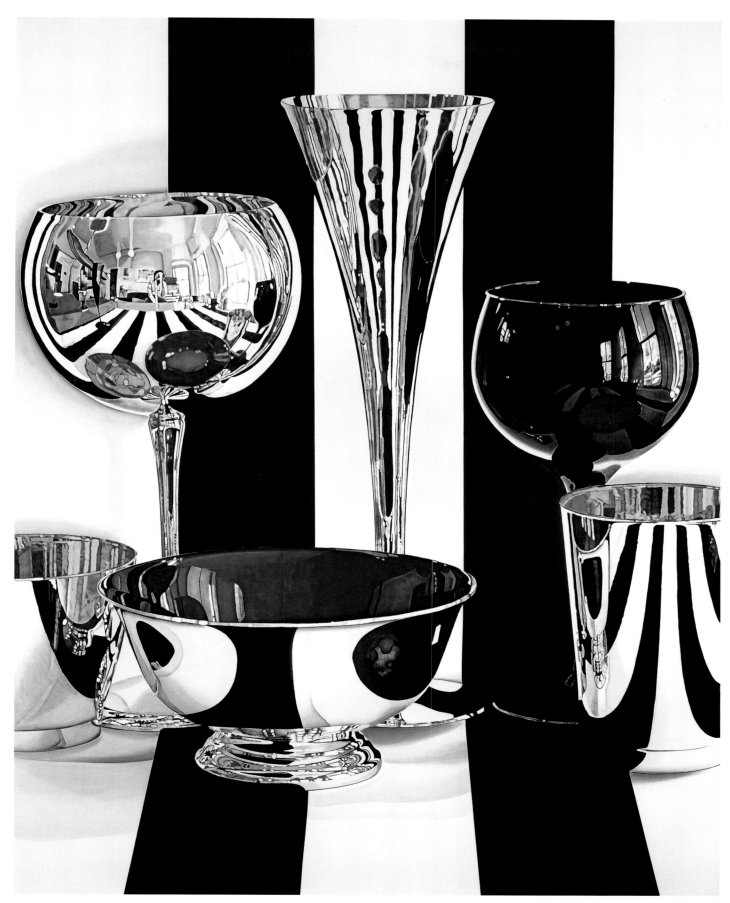

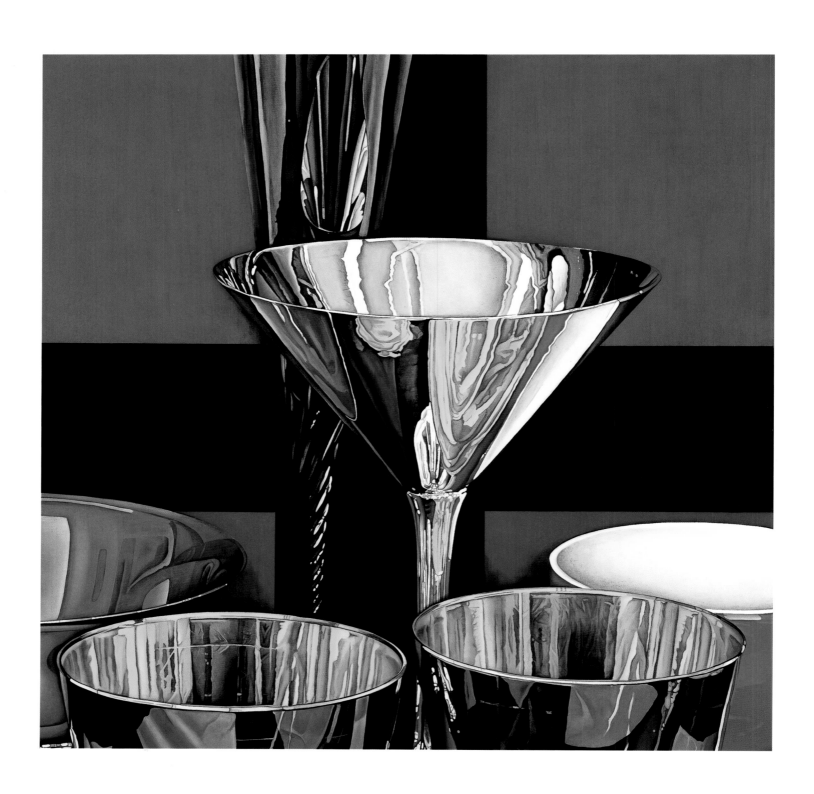

CROSSROAD MEMORY 1987, Oil on linen, 64 × 64 in.
Private collection

CHALICE 1986, Colored pencils on rag board, 17½ × 13⅜ in.
Meredith Catlell

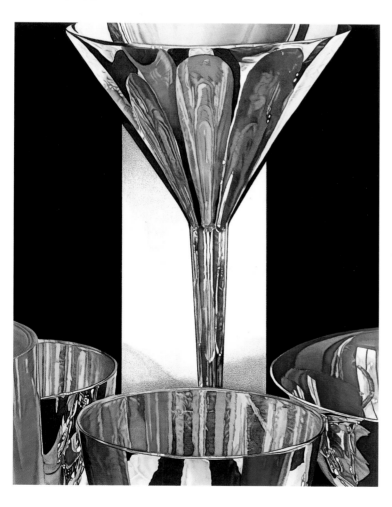

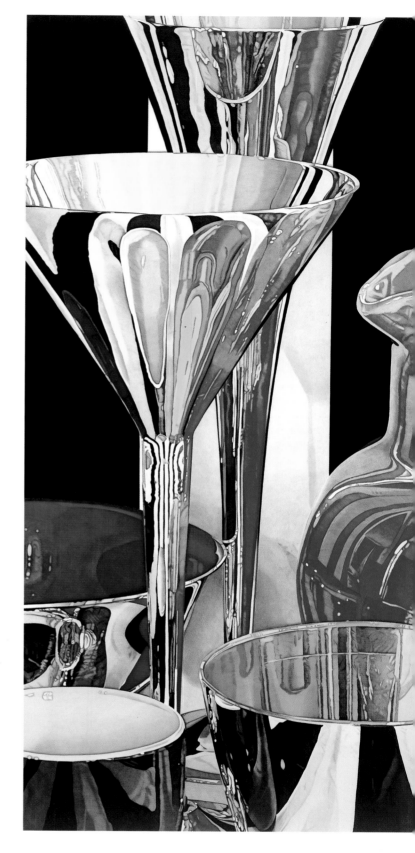

BLUE PITCHER 1986, Colored pencils on rag board, 54 × 26 in.
Sonnenschein, Nath, and Rosenthal, Chicago

79

UNTITLED 1987, Colored pencils on rag board,
8⅝ × 37½ in.
Location unknown

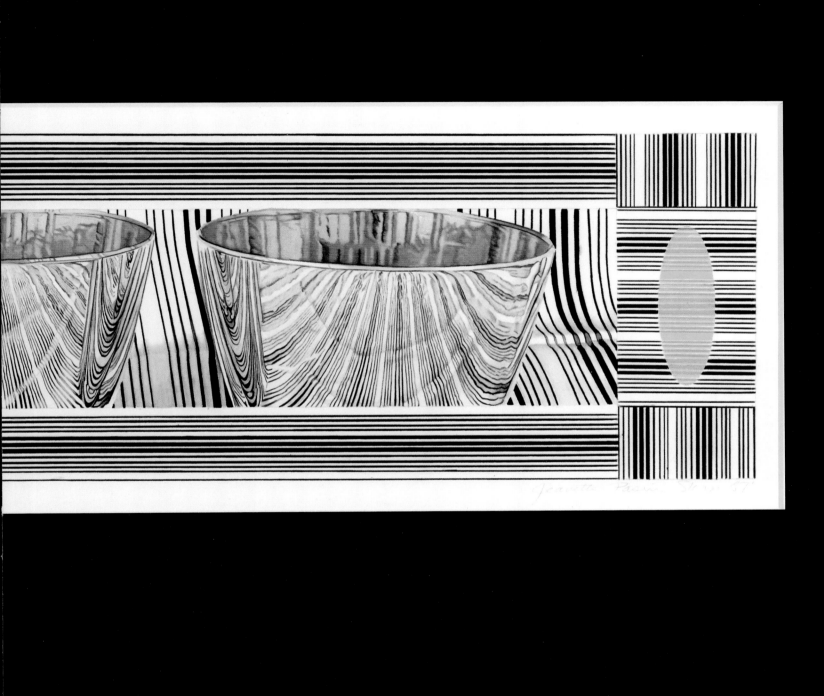

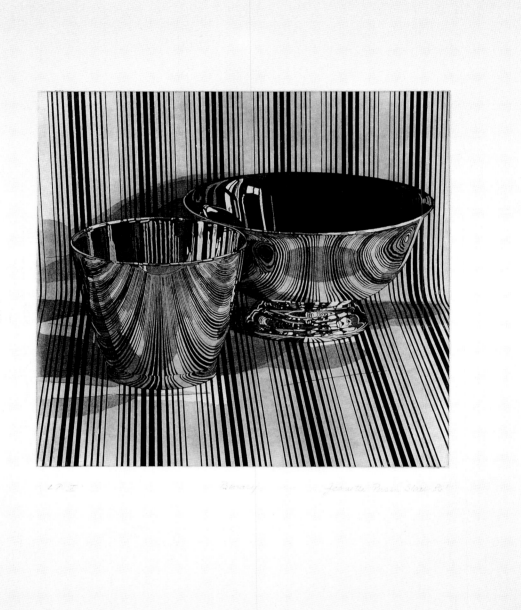

BINARY 1986, Aquatint/etching, 24 × 22 in.
Published by Landfall Press, Inc., Chicago

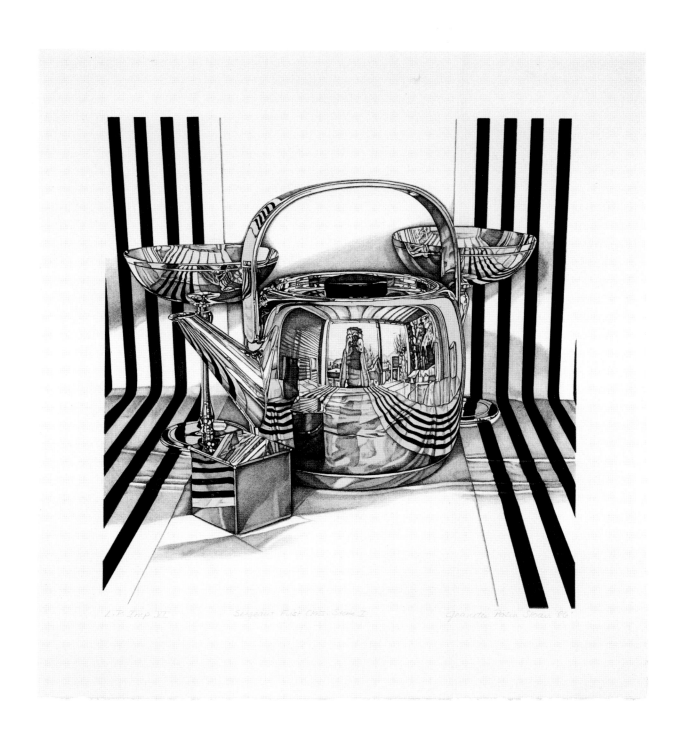

SERGEANT FIRST CLASS 1986, Black-and-white state lithograph, 24 × 22 in.
Published by Landfall Press, Inc., Chicago

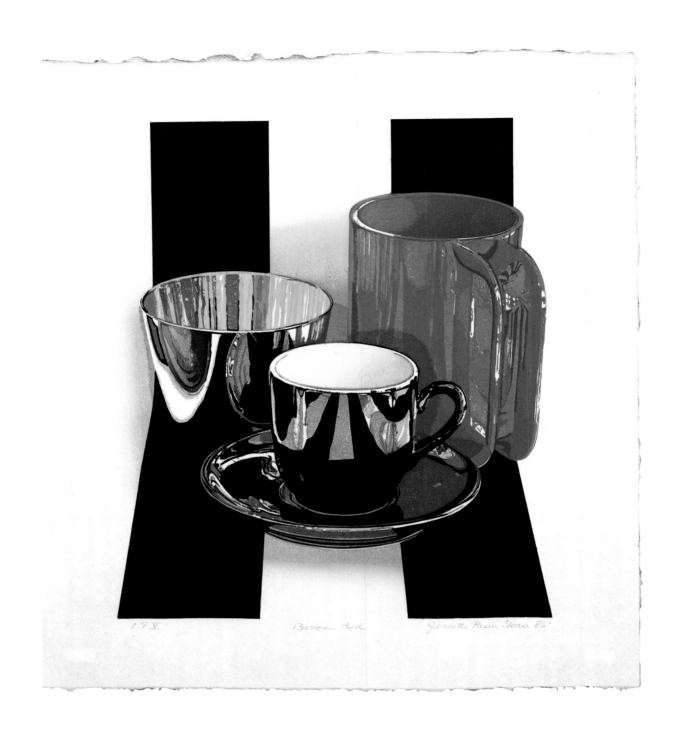

L.P. V Boston Red Jeanette Pasin Sloan 86'

BOSTON RED 1986, Woodcut, 24 × 22 in.

Published by Landfall Press, Inc., Chicago

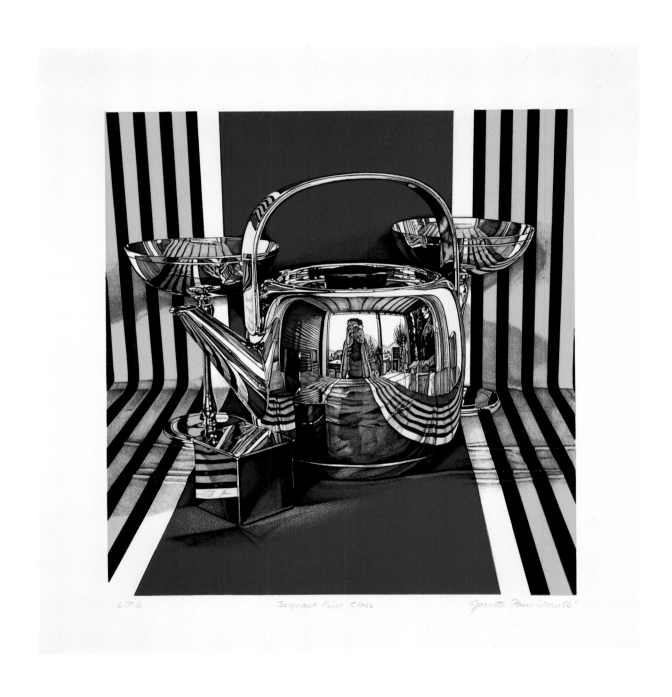

L.P.6. Sergeant First Class Jeanette Pasin Sloan 86'

SERGEANT FIRST CLASS 1986, Lithograph, 24 × 22 in.

Published by Landfall Press, Inc., Chicago

LA TERRAZZA 1986, Lithograph, 27 × 22 in.
Published by John Szoke Graphics, Inc., New York

REVERE REVERE 1988, Colored pencils on rag board, 30 × 34 in.
Elyce and Mark Metzner

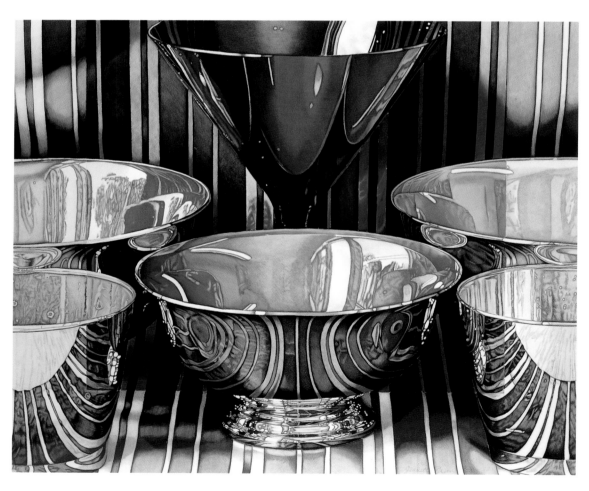

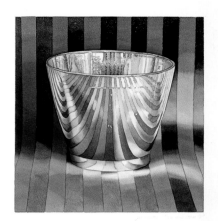

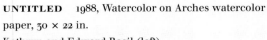
UNTITLED 1988, Watercolor on Arches watercolor paper, 30 × 22 in.
Kathryn and Edward Basil (left)

UNTITLED 1988, Watercolor on Arches watercolor paper, 30 × 22 in.
Location unknown (bottom left)

UNTITLED 1988, Watercolor on Arches watercolor paper, 30 × 22 in.
Location unknown (below)

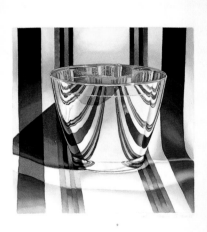

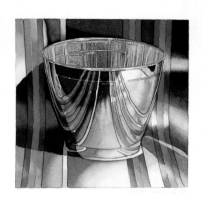

UNTITLED 1988, Watercolor on Arches watercolor paper, 30 × 22 in.
Location unknown (opposite)

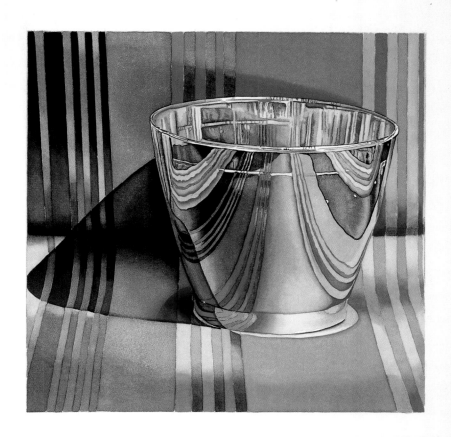

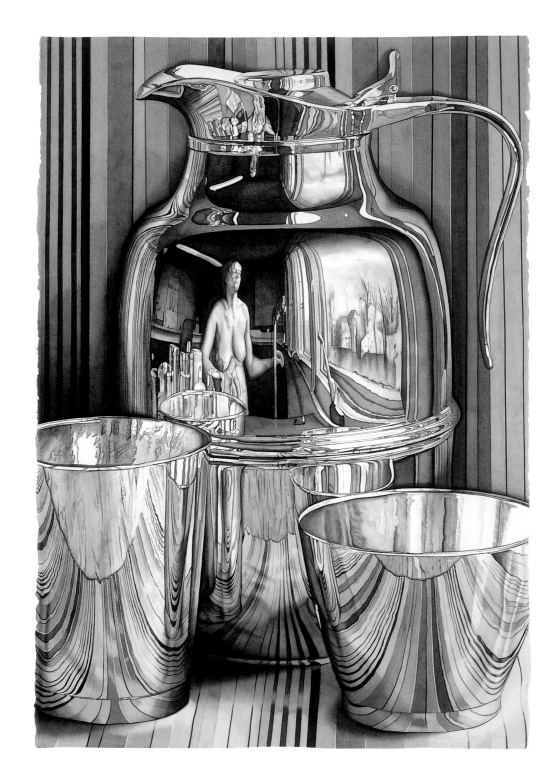

UNTITLED 1989, Watercolor on Arches watercolor paper, 60 × 40 in.
Stuart Handler family

EMERGENCE 1989, Watercolor on Arches watercolor paper, 63 × 43 in.
Dr. Karen Weinstein and Les Weinstein (opposite)

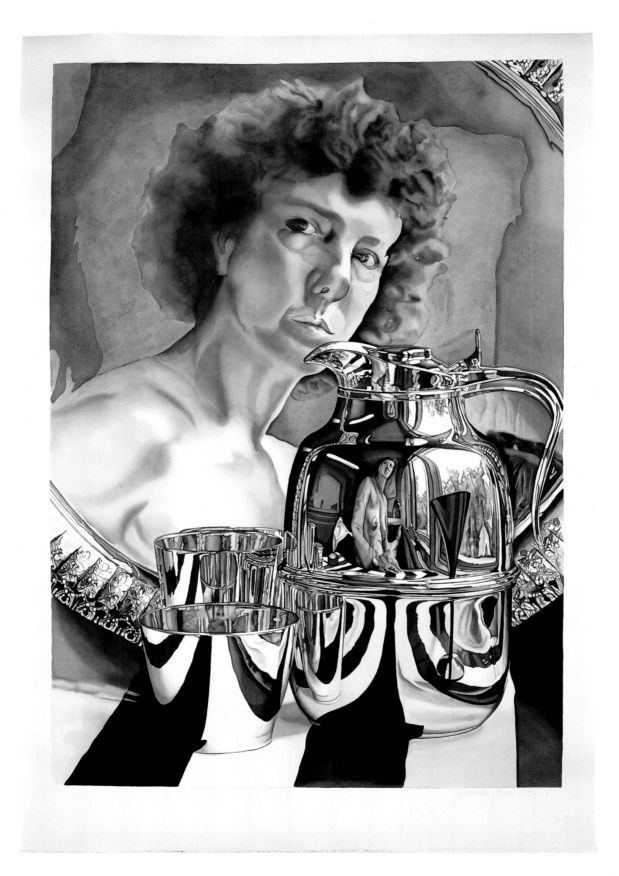

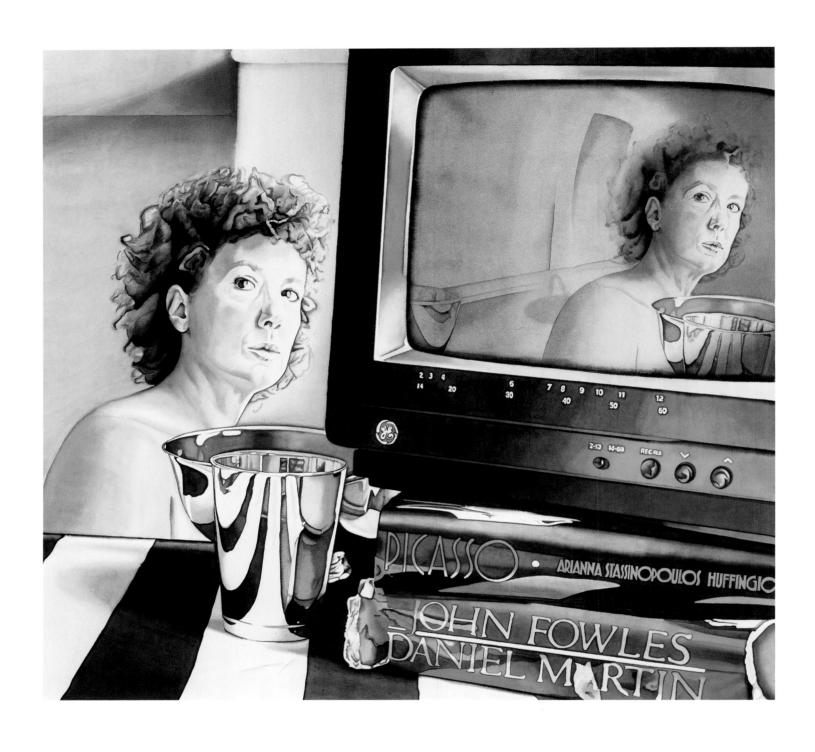

HALF-TIME 1989, Watercolor on Arches watercolor paper, 37 × 40 in.
Elizabeth and Bruce Jacobs

UNTITLED 1991, Watercolor and gouache on Arches watercolor paper, 47½ × 34½ in.
Jeanette Pasin Sloan

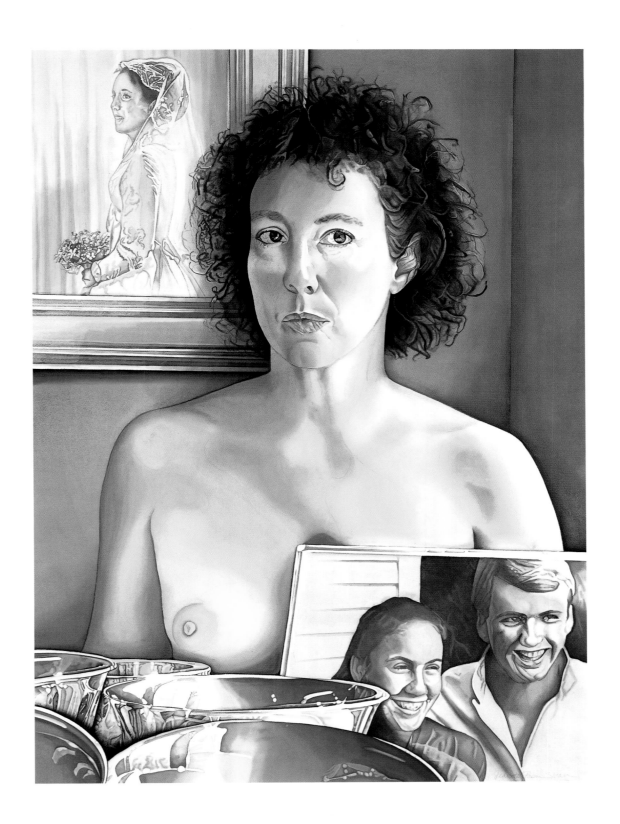

MOVING OUT 1990, Watercolor on Arches watercolor paper, 59½ × 46¾ in.
Mr. and Mrs. Hughes L. Potiker (opposite)

REVERE REVERE 1988–89, Oil on linen, 61 × 97 in.
Private collection

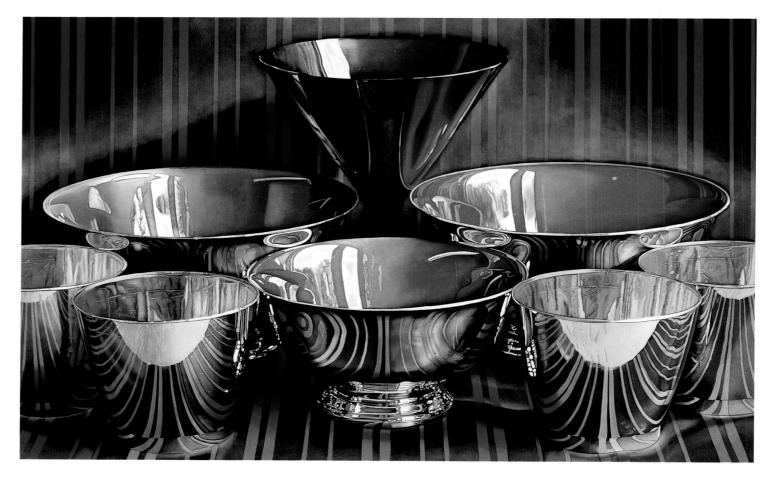

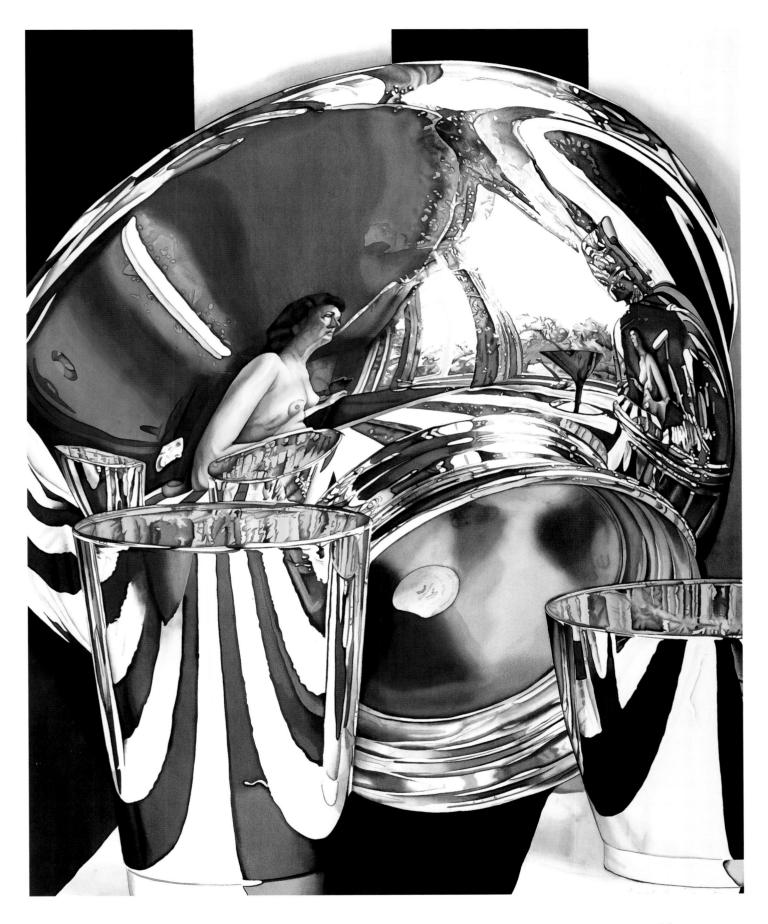

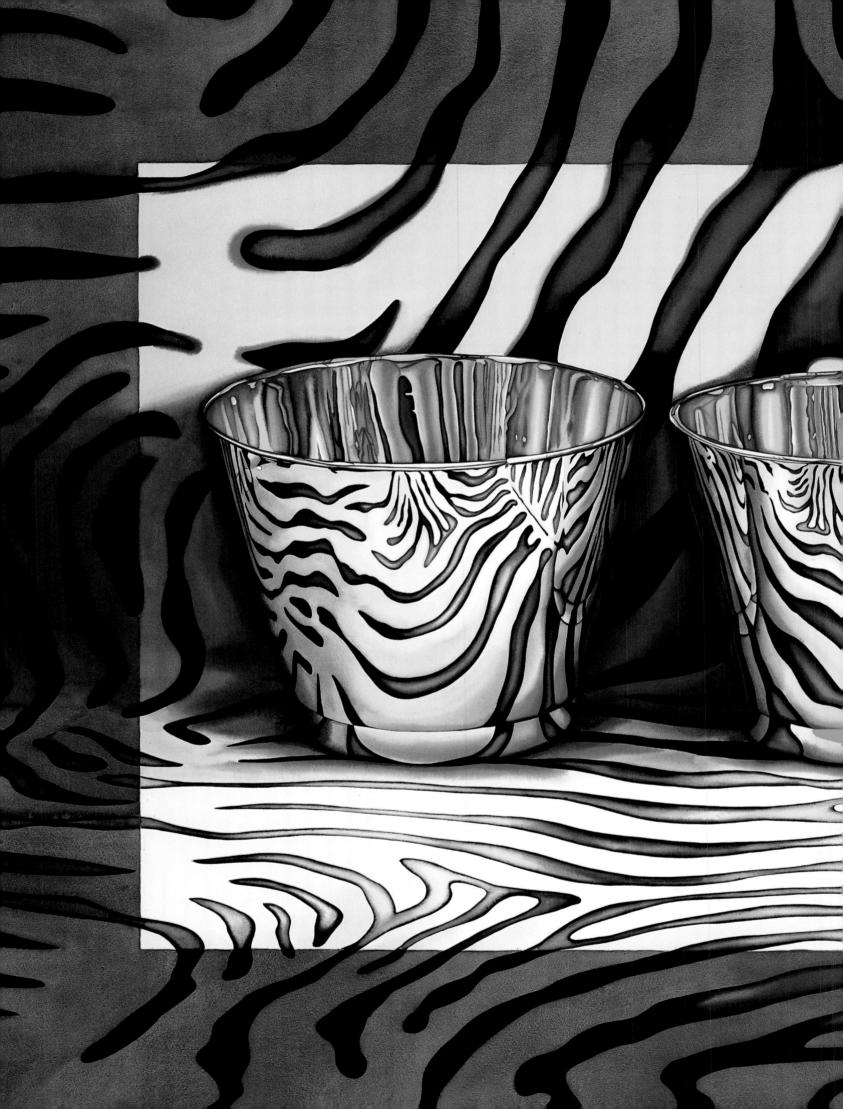

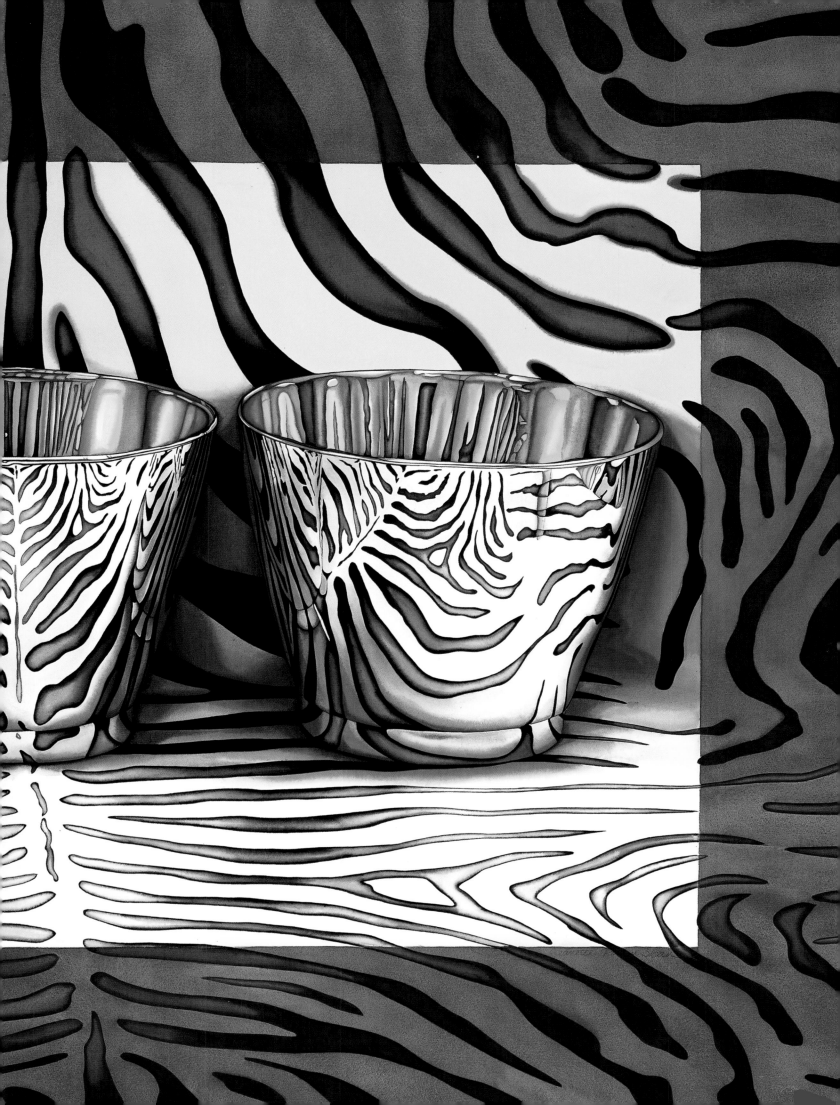

THREE ZEBRA CUPS 1997, Gouache and watercolor on Arches watercolor paper, 39 × 59 in.
Jeanette Pasin Sloan (preceding pages)

OCTAGONAL PITCHER 1997, Oil on linen, 36 × 34 in.
Diane and Donald Bennett

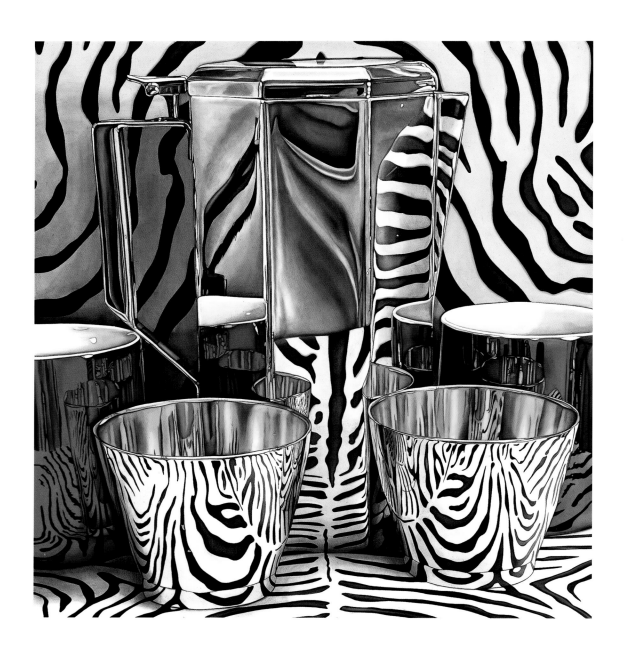

PENUMBRA 1991, Lithograph and etching, 22½ × 21½ in.
Published by Landfall Press, Inc., Chicago

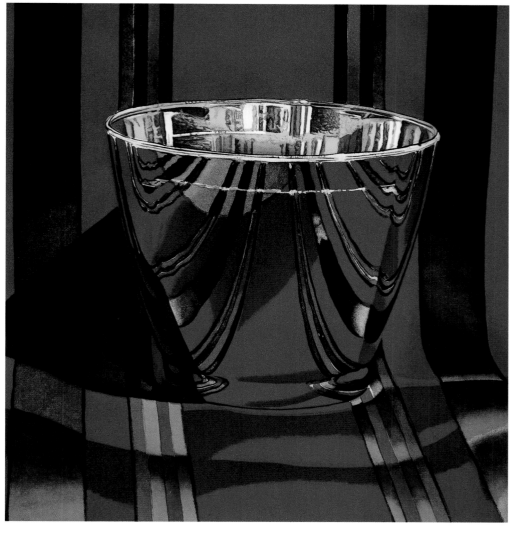

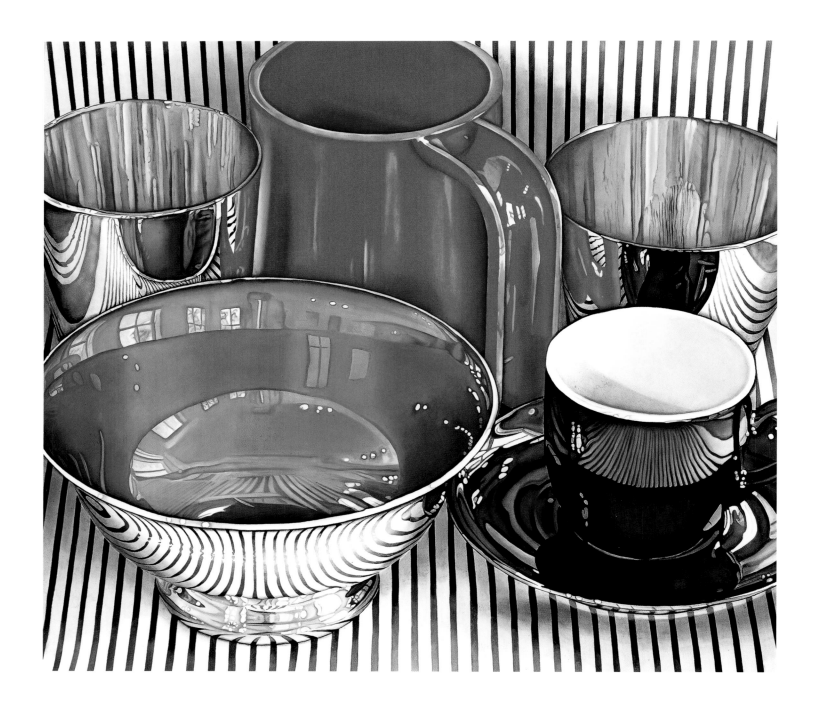

UNTITLED 1992, Oil on linen, 27 × 30 in.
Location unknown

100

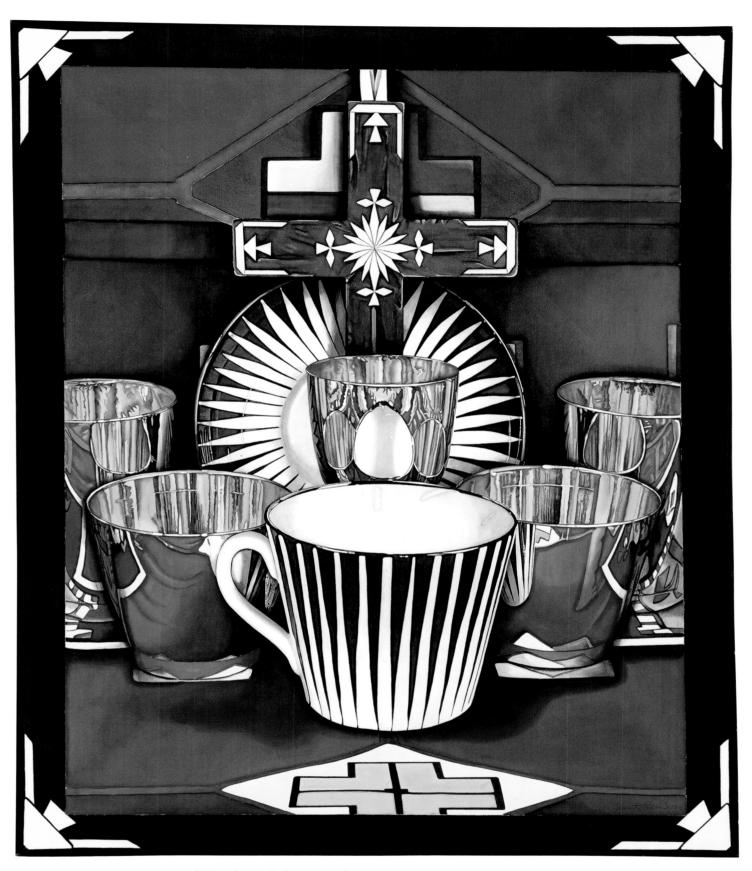

CHIMAYO CRUCES 1992, Watercolor on Arches watercolor paper, 50 × 42 in.
Roswell Museum and Art Center, Roswell, New Mexico

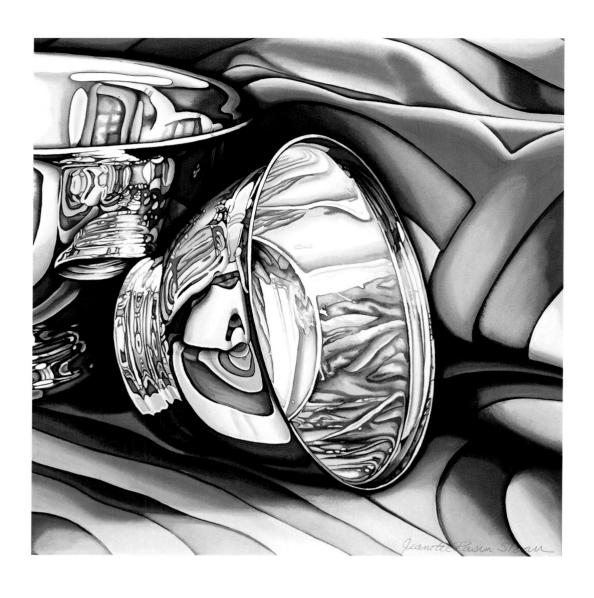

FIESTA STUDY 1993, Gouache and watercolor on rag board, 14 × 14 in. (image size)
Private collection

FIESTA 1993, Gouache and watercolor on Arches watercolor paper, 38 × 38 in.
Schnader, Harrison, Segal and Lewis

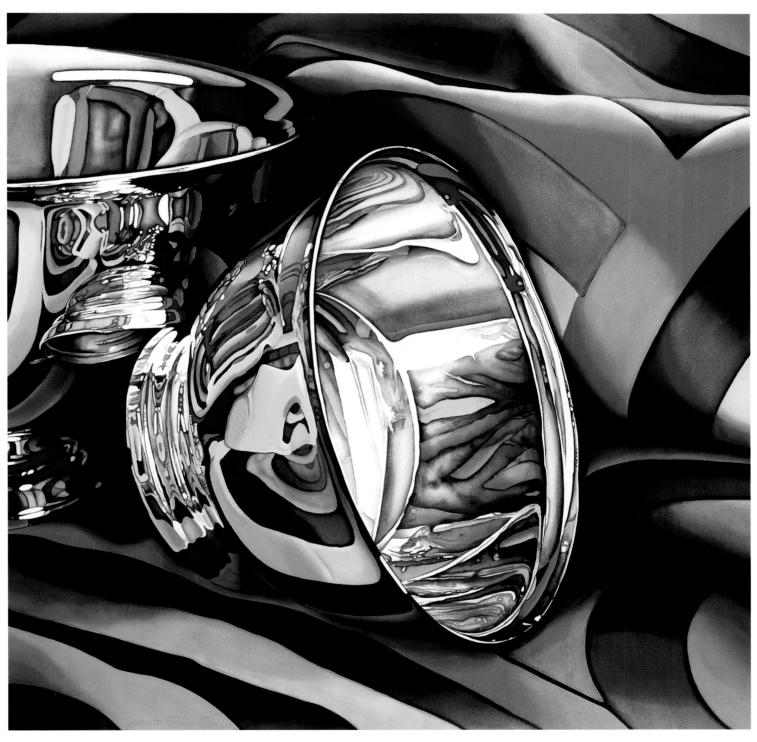

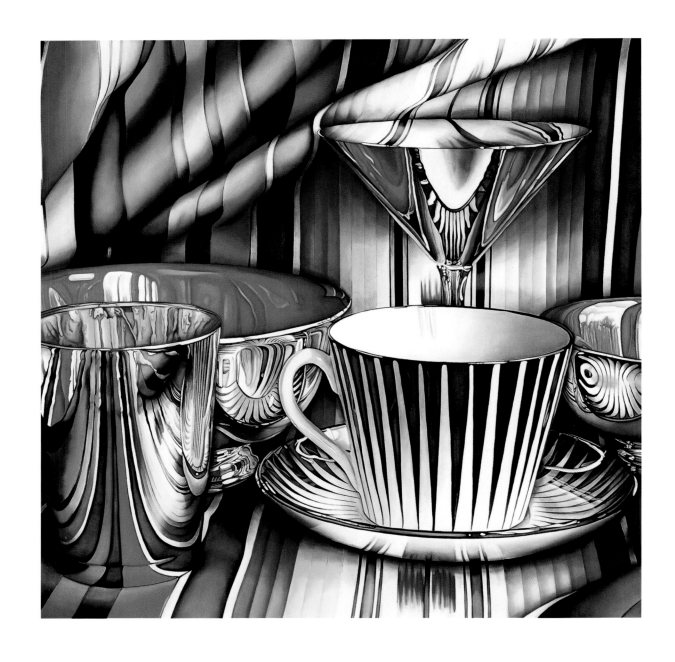

VALLE DE COLORE 1994, Oil on linen, 34 × 34 in.
Union League Club of Chicago

LOMA ARISCO 1993, Oil on linen, 34 × 34 in.
Darlene and Tom Furst

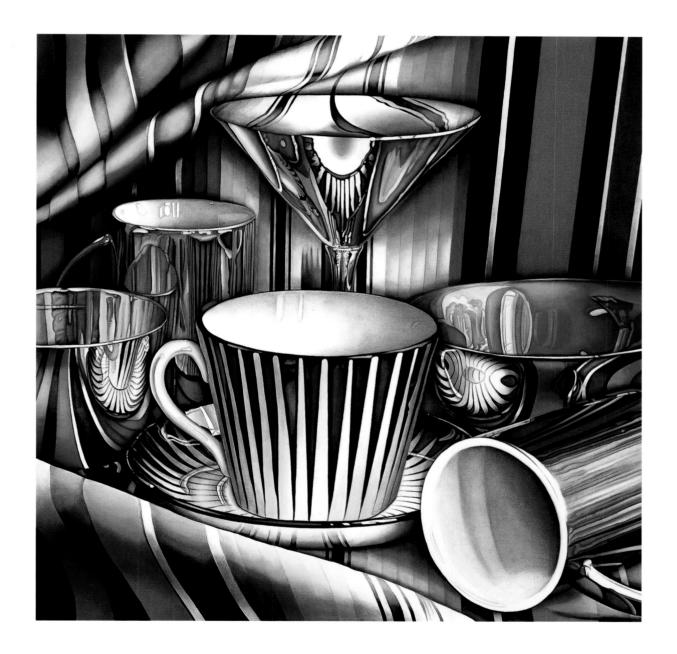

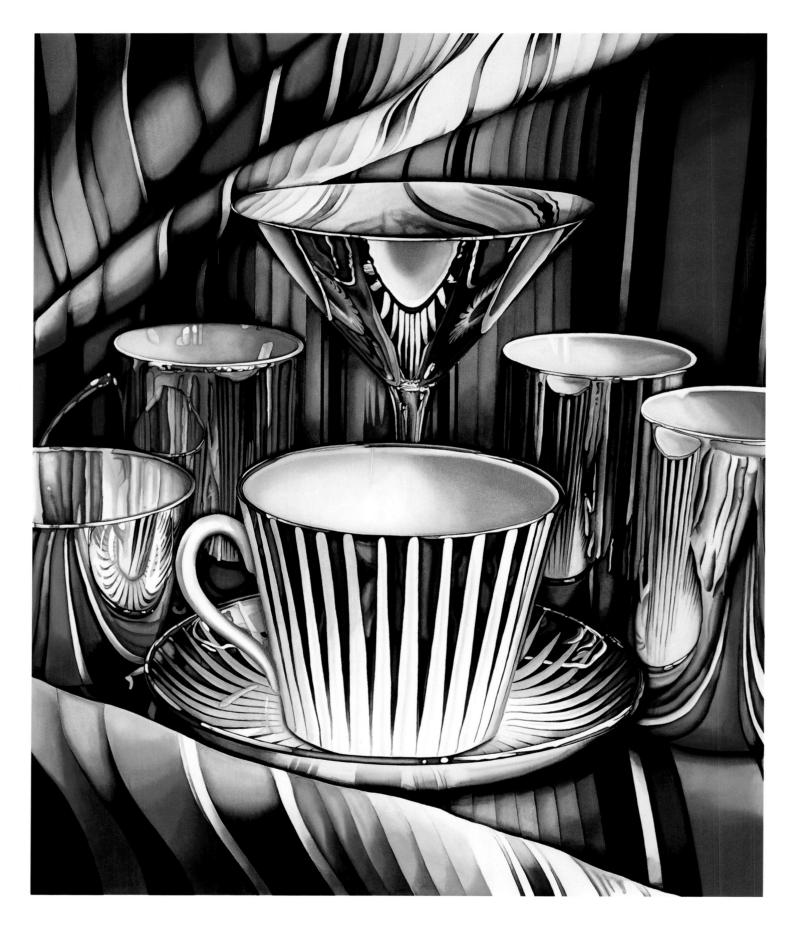

SUN DANCE 1993, Gouache and watercolor on Arches watercolor paper, 38½ × 31½ in.
Sebastian Garcia (opposite)

LA TERRAZZA 1994, Oil on linen, 22 × 24 in.
Janet and Christopher Graf

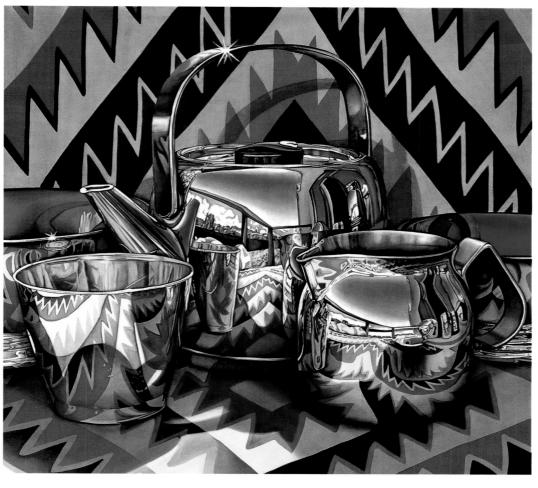

STUDY FOR LA FONDA 1995, Watercolor on Arches watercolor paper, 16 × 16 in. (left)

Gwynne and Robert Edmund

CASA DE LA LUZ 1994, Oil on linen, 32 × 34 in.

Jack Lunt (below)

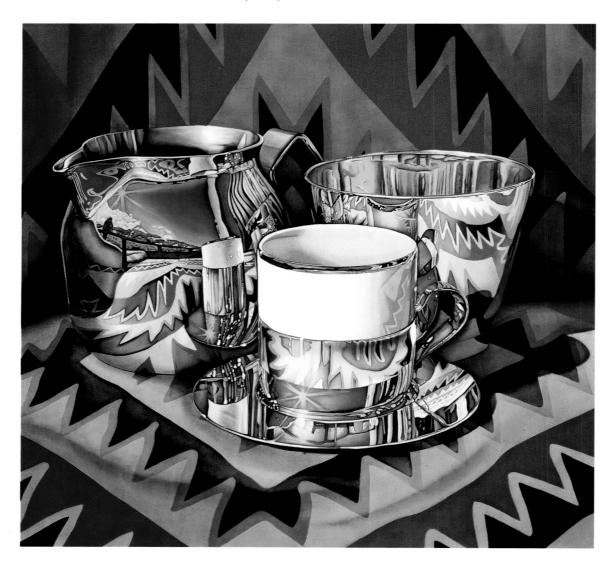

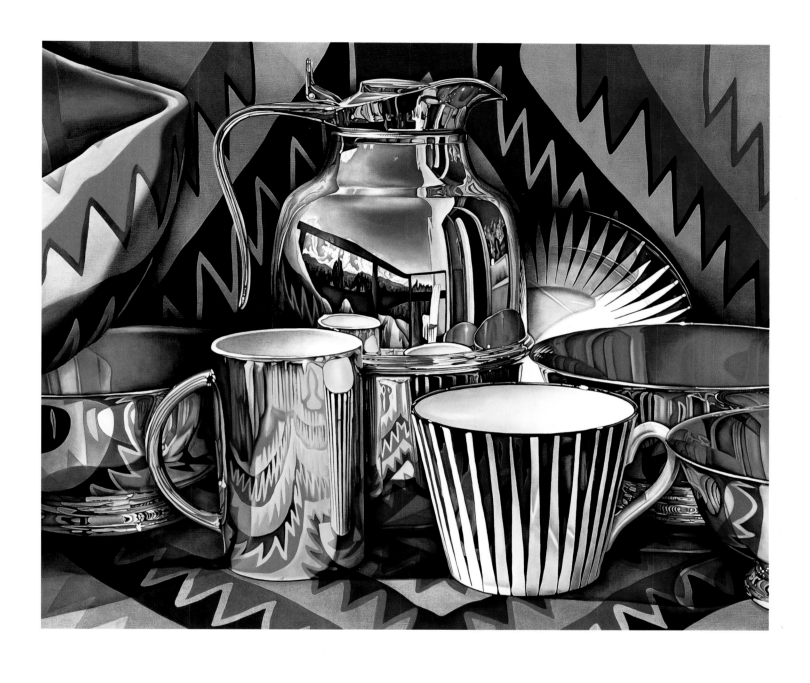

LA FONDA 1995, Oil on linen, 48 × 58 in.
Edith and Marvin S. Kaplan

SILVER SENTINEL c. 1997, Oil on linen, 49½ × 27 in.
Private collection (opposite)

BASSANO STRIPES 1996, Oil on linen, 28 × 36 in.
Private collection

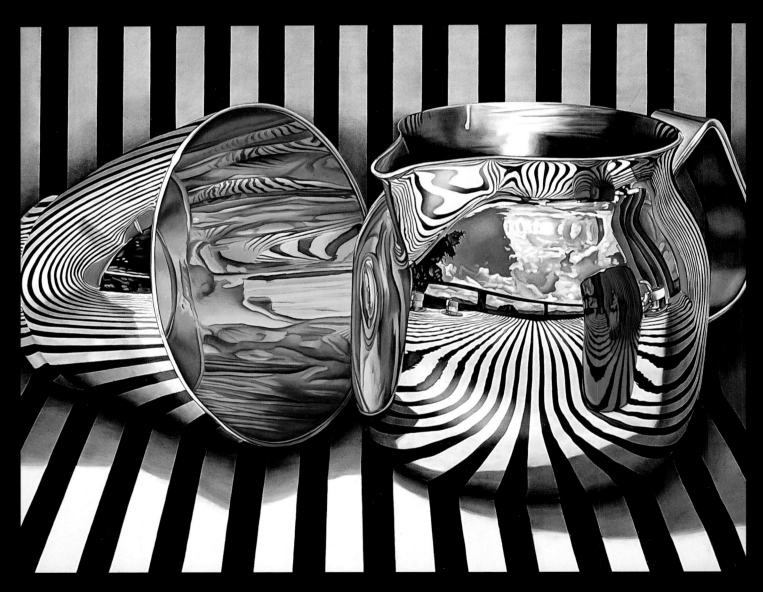

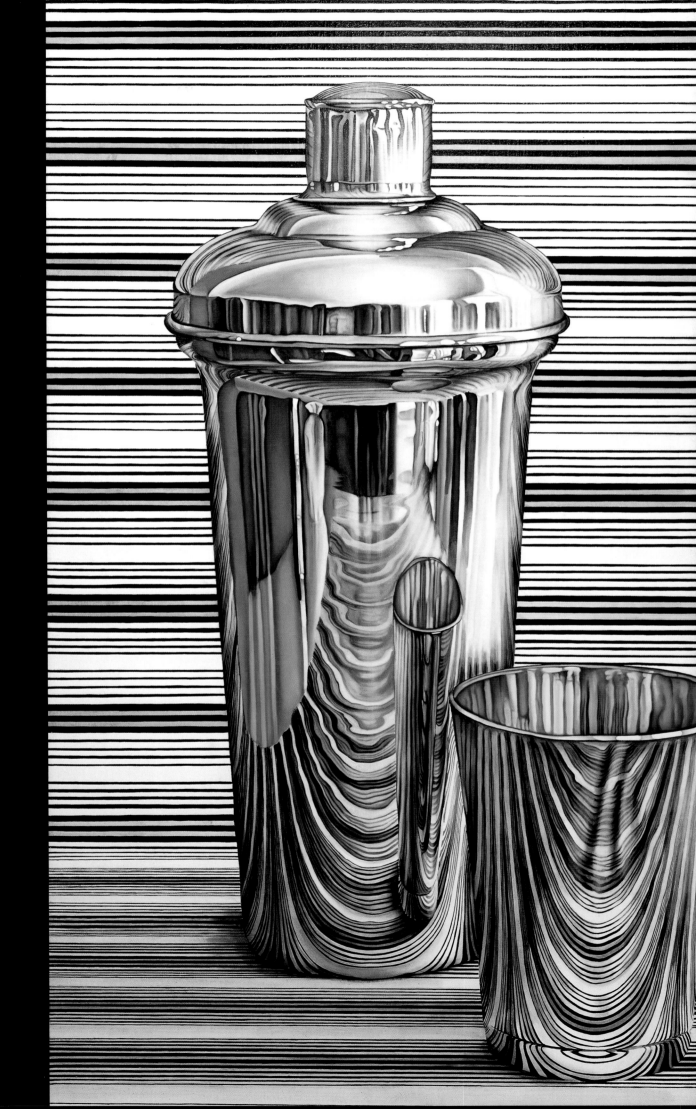

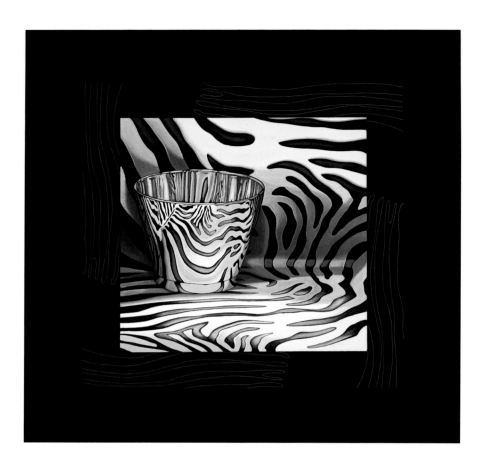

PULSAR I 1997, Gouache and watercolor on black rag board, 26 × 26 in.
Private collection

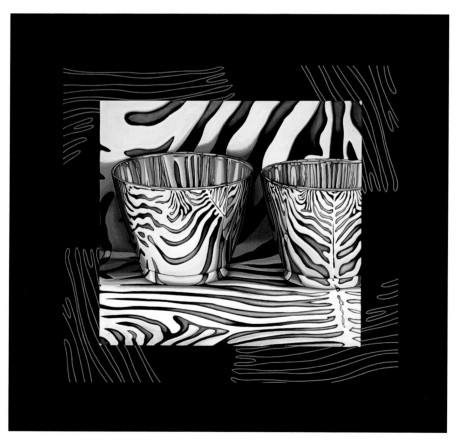

PULSAR II 1997, Gouache and watercolor on black rag board, 22 × 23 in.
Cleve Carney

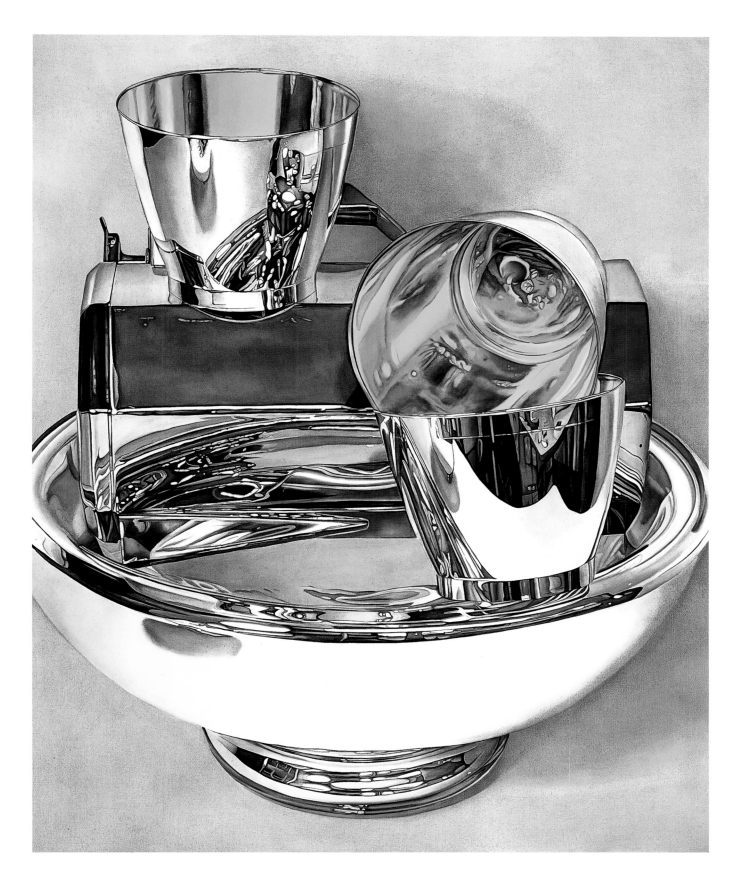

BALANCING ACT I 1997, Oil on linen, 40 × 32 in.
Private collection

BALANCING ACT II 1997, Oil on linen, 42 × 32 in.
Mr. Donald Knebel (opposite)

BALANCING ACT 1998, Digital graphic, 27 × 20 in.
Published by Landfall Press, Inc., Chicago

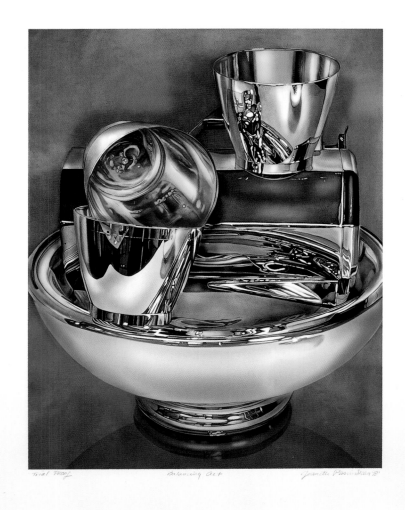

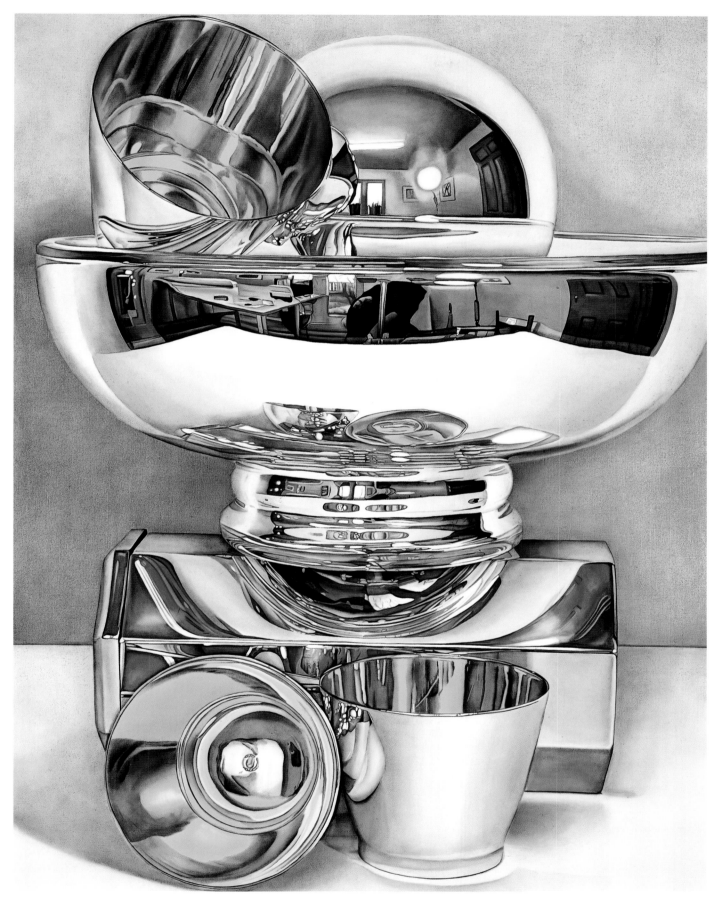

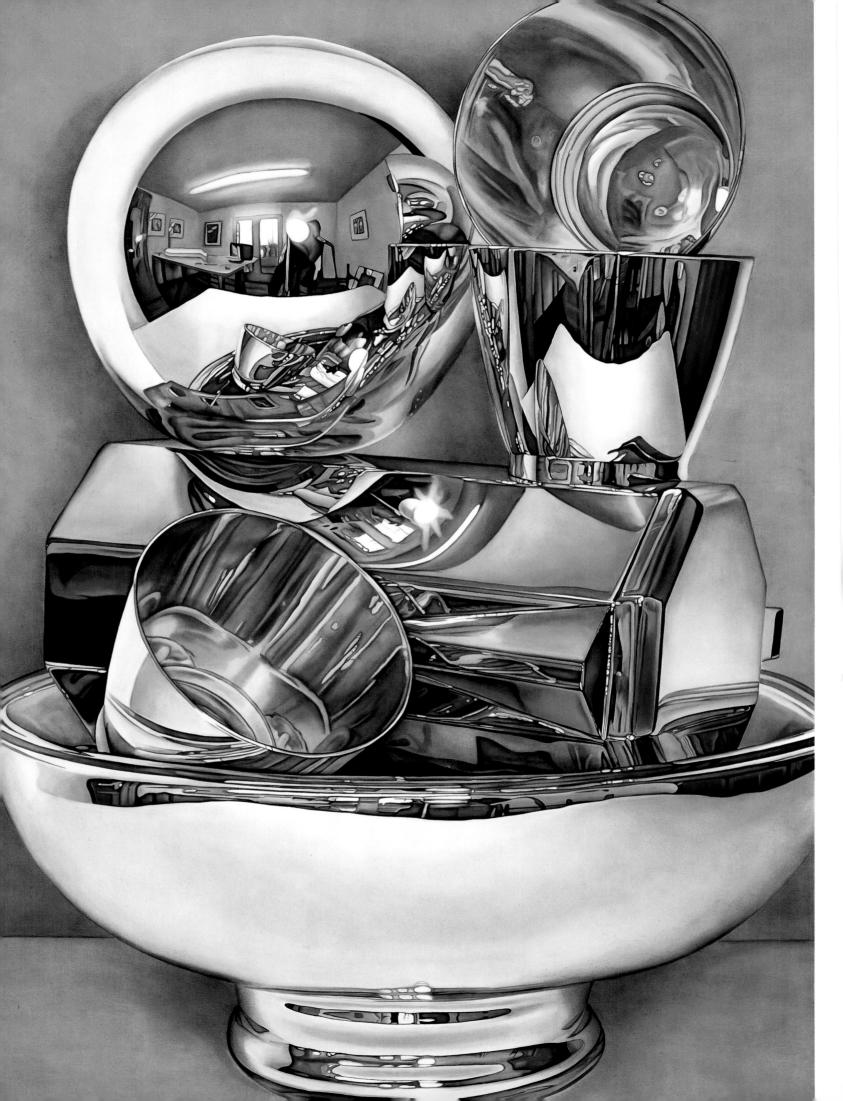

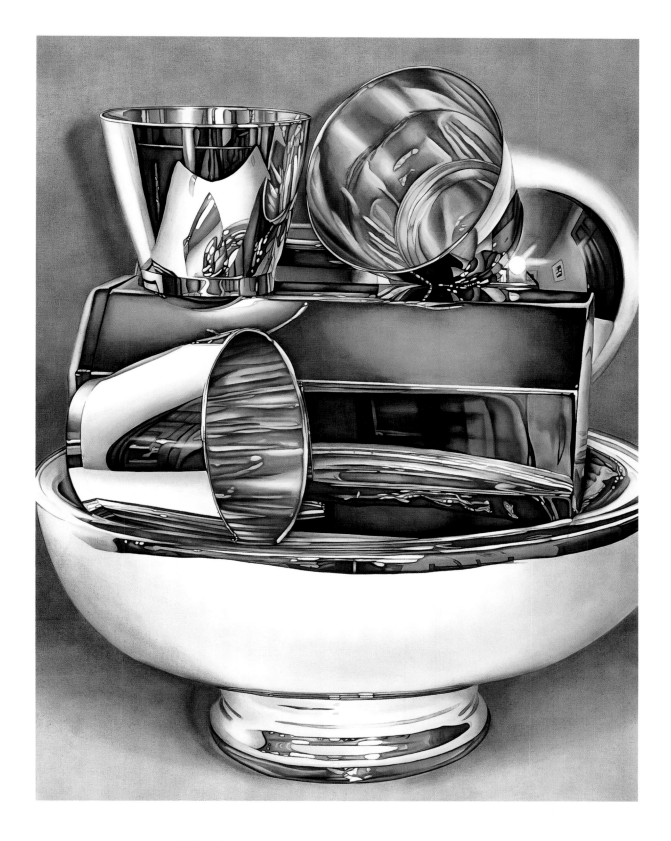

BALANCING ACT V 1998, Oil on linen, 40 × 30 in.
Brauer Museum of Art, Valparaiso Center for the Arts, Valparaiso, Indiana

BALANCING ACT III 1997–98, Oil on linen, 54 × 34 in.
Joe and Rebekah Humphry (opposite)

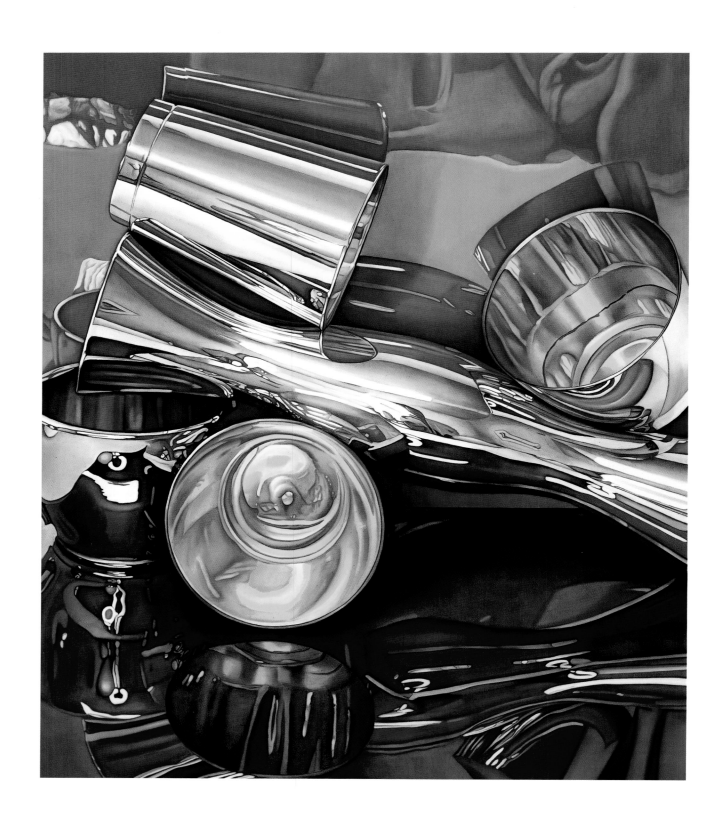

BALANCING ACT VI 1998, Oil on linen, 34 × 29 in.
Private collection

BALANCING ACT X 1998, Oil on linen, 28 × 24 in.
Bruce Robson

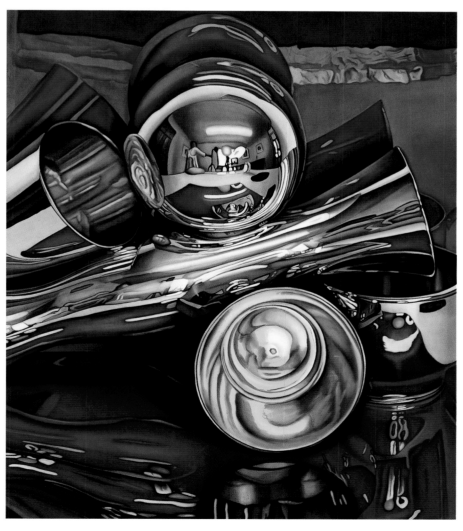

BALANCING ACT XI 1999, Oil on linen, 26 × 22 in.
Jeanette Pasin Sloan

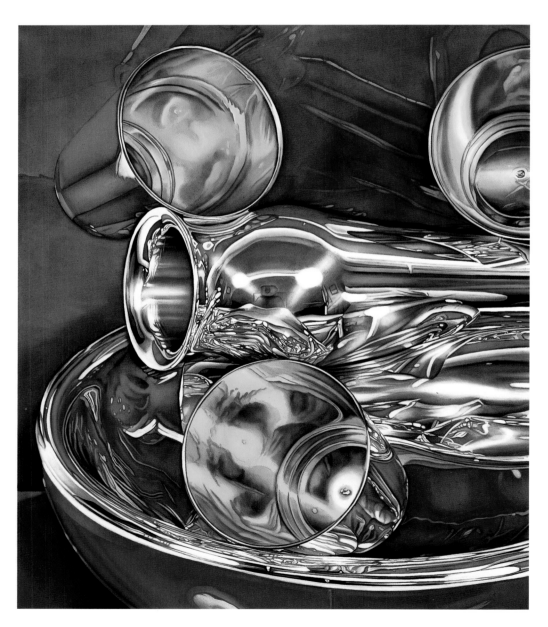

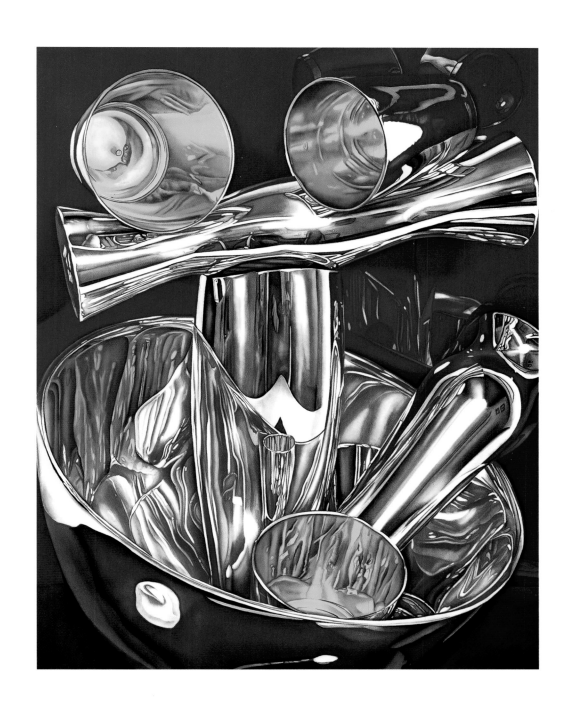

BALANCING ACT XVII 1999, Oil on linen, 28 × 22 in.
Jeanette Pasin Sloan

BALANCING ACT VIII 1999, Oil on linen, 28⅛ × 24½ in.
M.K.W. Partners L.P.

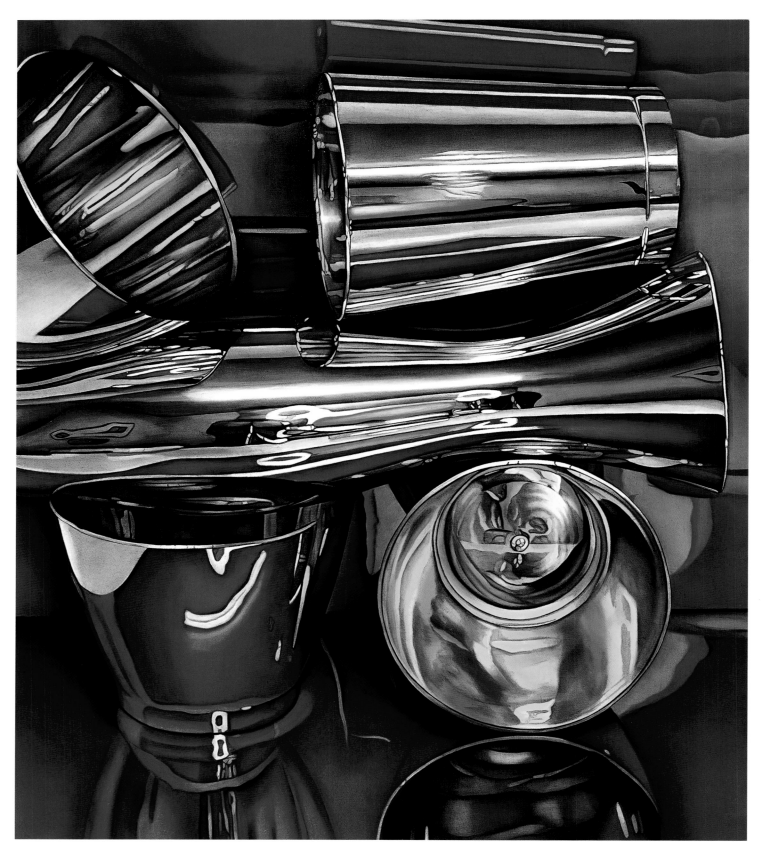

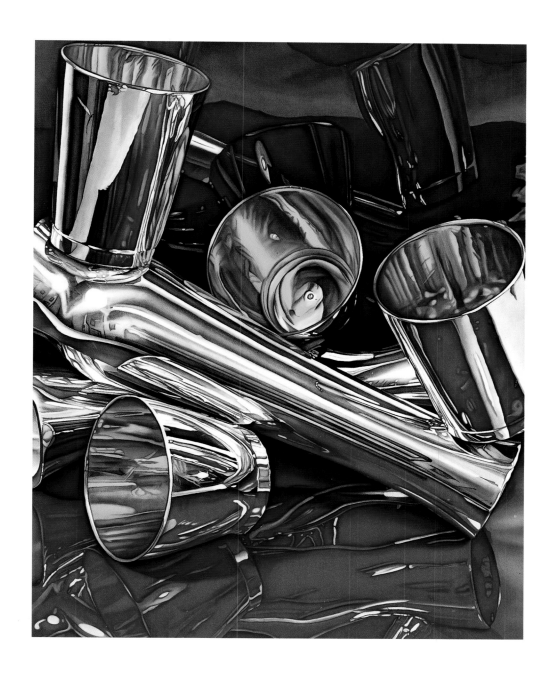

BALANCING ACT XV 1999, Oil on linen, 28 × 22 in.
Gerhard Wurzer Gallery, Houston

BALANCING ACT XIII 1999, Oil on linen, 28 × 22 in.
Private collection (overleaf)

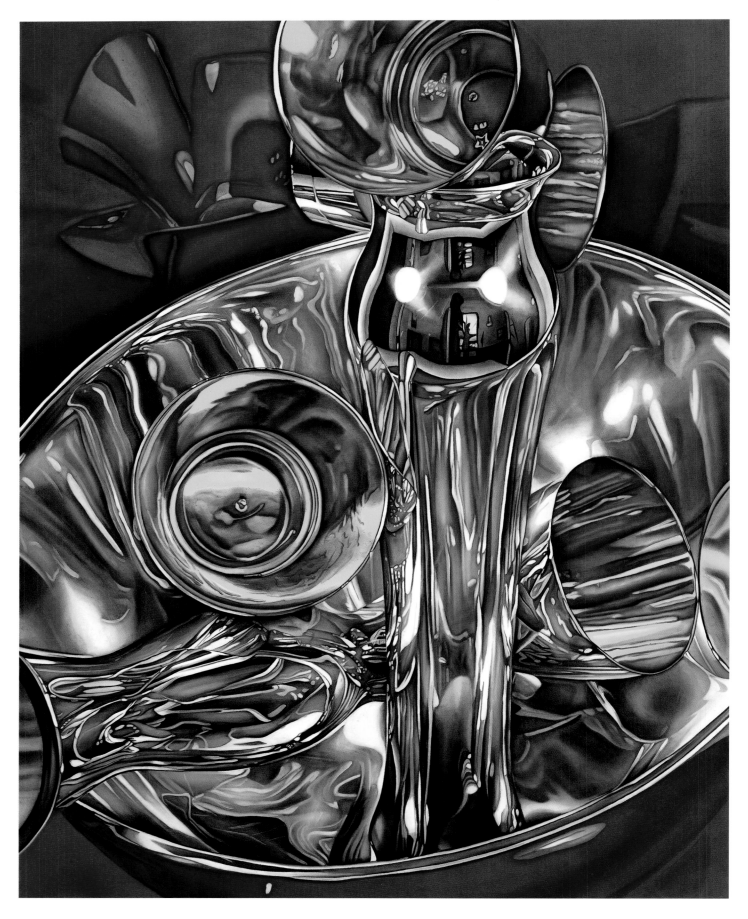

124

EXHIBITION HISTORY

SOLO EXHIBITIONS

1999
Tatistcheff and Company, Inc., New York
Peltz Gallery, Milwaukee, Wisconsin

1998
University Club of Chicago, Chicago
Cline Fine Art Gallery, Santa Fe, New Mexico
Frederick Baker, Inc., Chicago

1997
Tatistcheff and Company, Inc., New York
Gerhard Wurzer Gallery, Houston
Benedictine University, Lisle, Illinois
Deborah Lovely Fine Arts, Oakbrook Terrace, Illinois

1996
Butters Gallery, Ltd., Portland, Oregon
Union League Club of Chicago, Chicago

1995
Tatistcheff and Company, Inc., New York (catalogue)

Butters Gallery, Ltd., Portland, Oregon
University of Wisconsin–Milwaukee (catalogue)
Peltz Gallery, Milwaukee, Wisconsin
Quartet Editions, New York

1994
Butters Gallery, Ltd., Portland, Oregon
Landfall Press Gallery, Chicago

1993
Thimmesh Gallery, Minneapolis

1992
Roger Ramsay Gallery, Chicago (catalogue)

1991
Butters Gallery, Ltd., Portland, Oregon

1990
Peltz Gallery, Milwaukee, Wisconsin
Camino Real Gallery, Boca Raton, Florida

1989
Peltz Gallery, Milwaukee, Wisconsin
Butters Gallery, Ltd., Portland, Oregon

Tatistcheff Gallery, Santa Monica, California
Steven Scott Gallery, Baltimore
Patrick Gallery, Austin, Texas
Roger Ramsay Gallery, Chicago

1988
Adams-Middleton Gallery, Dallas

1987
Leedy-Voulkos Gallery, Kansas City, Missouri
David Adamson Gallery, Washington, D.C.
Saginaw Art Museum, Saginaw, Michigan
Roger Ramsay Gallery, Chicago (catalogue)
Peter M. David Gallery, Minneapolis

1985
Sister Guala O'Connor Gallery, Rosary College,
River Forest, Illinois
G. W. Einstein Company, Inc., New York

1984
Kirkland Fine Arts Center Gallery, Millikin
University, Decatur, Illinois

1983
G. W. Einstein Company, Inc., New York

1982
Illinois State Museum, Springfield

1981
Frumkin and Struve Gallery, Chicago

1980
G. W. Einstein Company, Inc., New York

1979
G. W. Einstein Company, Inc., New York

1978
Landfall Press Gallery, Chicago

1977
G. W. Einstein Company, Inc., New York

1976
University Club of Chicago, Chicago
Galesburg Civic Art Center, Galesburg, Illinois

1975
North River Gallery, Northeastern Illinois
University, Chicago

GROUP EXHIBITIONS

2000
Prints by American Artists, Wichita Falls Museum
and Art Center, Wichita Falls, Texas
The Figure at the Millennium, Art Gallery Fine
Arts Center, Northeastern Illinois University,
Chicago
Out of Line, Sidney R. Yates Gallery, Chicago
Cultural Center, Chicago

1999
*Contemporary American Realist Drawings from
the Jalane and Richard Davidson Collection,* Art
Institute of Chicago (catalogue)
Re-presenting Representation IV, Arnot Art
Museum, Elmira, New York (catalogue)

1998
*Pushing Boundaries: Lithographs from Nine
American Fine Art Presses,* DAAP Galleries,
University of Cincinnati, Cincinnati, Ohio
(catalogue)
Remarkable Women Show, Peltz Gallery,
Milwaukee, Wisconsin

1997
International Print Exposition, Portland Art
Museum, Portland, Oregon
September Group Exposition, Tatistcheff and
Company, Inc., New York
All That Glitters, Jean Albano Gallery, Chicago
*Rethinking Realism: Contemporary American
Watercolors,* Suzanne H. Arnold Art Gallery,
Lebanon Valley College of Pennsylvania, Annville

1996
Objects of Personal Significance: Exhibits USA,
traveling exhibition organized by Mid-America
Arts Alliance (catalogue)
Landfall Press: Twenty-five Years of Printmaking,
Milwaukee Art Museum (catalogue)
Second Sight: Printmaking in Chicago, 1935–1995,
Mary and Leigh Block Gallery, Northwestern
University, Evanston, Illinois (catalogue)

Beacon Hill Fine Art Celebrates 20 Years of Collecting by the Federal Reserve Board, Beacon Hill Fine Art, New York (catalogue)

1995

Contemporary American Realism, Elliot Smith Contemporary Art, St. Louis

The Art of Watercolor, Luise Ross Gallery, New York

The Lure of Color, Champion International Corporation Headquarters, Stamford, Connecticut

On the Table, Steven Scott Gallery, Baltimore

Harvest Moon, Tatistcheff/Rogers Gallery, Santa Monica, California

Women in Print: Prints from 3M by Contemporary Women Printmakers, Concourse Gallery, 3M, St. Paul, Minnesota (catalogue)

1994

Summer, Tatistcheff and Company, Inc., New York

Small Works, Thimmesh Gallery, Minneapolis

Realism in Our Time, Broden Gallery, Ltd., Madison, Wisconsin

American Realism and Figurative Painting, Cline Fine Art Gallery, Santa Fe, New Mexico (catalogue)

Realism '94, Fletcher Gallery, Santa Fe, Mexico

Setting the Table: Contemporary Still Life Art, Louisville Visual Art Association, Louisville, Kentucky (brochure)

Telling It Like It Is: Realism in Paintings, Drawings and Prints, Peltz Gallery, Milwaukee, Wisconsin

18th Annual National Invitational Drawing Exhibition, Norman R. Eppink Art Gallery, Emporia State University, Emporia, Kansas

Contemporary American Works of Art on Paper, Madigan Library, University of Michigan, Dearborn (catalogue)

1993

The Anniversary Show, Tatistcheff/Rogers Gallery, Santa Monica, California

Celebrations, G. W. Einstein Company, Inc., New York

Summer Group Exhibition, Tatistcheff and Company, Inc., New York

1992

Interiors, Steven Scott Gallery, Baltimore

Prints by Contemporary Women Artists, Callen McJunkin Gallery, Charleston, West Virginia

In Celebration of Women, David Adler Cultural Center, Libertyville, Illinois

Face to Face: Self-Portraits by Chicago Artists, Exhibit Hall, Chicago Cultural Center, Chicago

1991

Realism Re-Examined, Landfall Press Gallery, New York

Contemporary Still Lifes, Steven Scott Gallery, Baltimore

Group Show, Landfall Press Gallery, Chicago

Landfall Press Exhibit, Federal Reserve Bank of Chicago, Chicago

Annual Remarkable Women Show, Peltz Gallery, Milwaukee, Wisconsin

Summer Pleasures, Steven Scott Gallery, Baltimore

Still Life: Paintings and Drawings, Tatistcheff Gallery Inc., Santa Monica, California

Watercolor across the Ages, The Gallery at Bristol-Myers Squibb, Princeton, New Jersey (catalogue)

Printing Now, Leedy-Voulkos Gallery, Kansas City, Missouri

Presswork: The Art of Women Printmakers, National Museum of Women in the Arts, Washington, D.C. (catalogue)

Recent Watercolors and Monotypes, Steven Scott Gallery, Baltimore

Five Artists, Landfall Press Gallery, New York

1990

In the Garden, Steven Scott Gallery, Baltimore

Twenty Years of Landfall Press, Landfall Press Gallery, Chicago

Women in the Visual Arts, Harbert Schoolhouse Gallery, Harbert, Michigan

The Mary Jean Thomson Collection, Community Gallery of Art, College of Lake County, Grayslake, Illinois

1989

Chicago Painters in Print, Landfall Press Gallery, Chicago

Prints from Press, San Antonio Art Institute, San Antonio, Texas

78th Annual Exhibition: Chicago, Maier Museum of Art, Randolph-Macon Woman's College, Lynchburg, Virginia (brochure)

Watercolor: Contemporary Currents, Riverside Art Museum, Riverside, California

Meticulous Realist Drawing, Squibb Gallery, Princeton, New Jersey (catalogue)

Perspective in Realism, Landfall Press Gallery, Chicago and New York

1988

The Print Society: Tenth Anniversary Exhibition, Nelson-Atkins Museum of Art, Kansas City, Missouri

Landfall Press Exhibit, Dean Jensen Gallery, Milwaukee, Wisconsin

Landfall Press Exhibit, Mark Ruschman Gallery, Indianapolis, Indiana

1987

"A Just Temper between Propensities": New Still-Life and Landscape Painting, Bayly Art Museum, University of Virginia, Charlottesville (catalogue)

Drawing: The New Tradition, Huntsville Museum of Art, Huntsville, Alabama

Mainstream America: The Collection of Phil Desing, Butler Institute of American Art, Youngstown, Ohio

Woodcuts, Landfall Press Gallery, New York

Close Focus: Prints, Drawings and Photographs, National Museum of American Art, Washington, D.C.

Pulled and Pressed: Contemporary Prints and Multiples, David Winton Bell Gallery, Brown University, Providence, Rhode Island

Landfall Press: Selections from the Permanent Collection, Art Institute of Chicago

National Drawing Invitational, Arkansas Arts Center, Little Rock (catalogue)

1986

66th Annual Artist Member Exhibition, Arts Club of Chicago

Landfall Press: Selections from the Permanent Collections, Art Institute of Chicago

1985

Contemporary American Still Life, One Penn Plaza, New York

Drawings: The Eighty-first Exhibition by Artists of Chicago and Vicinity, Art Institute of Chicago (catalogue)

Midwest Realists, Paine Art Center and Arboretum, Oshkosh, Wisconsin

The Atelier in America, Swen Parson Gallery, Northern Illinois University, DeKalb (catalogue)

1984

Aspects of Contemporary Realism, Jerald Melberg Gallery, Charlotte, North Carolina

Opening Exhibition, G. W. Einstein Company, Inc., New York

Connexions: Celebrating Life and the Arts, Fourth Presbyterian Church, Chicago

Fine Art Prints for Collectors, Norris Gallery, Dellora A. Norris Cultural Arts Center, St. Charles, Illinois

Four Brothers Press Exhibition of Lithographs, Morton College Art Gallery, Cicero, Illinois

1983

Printed by Women, Port of History Museum at Penn's Landing, Philadelphia (catalogue)

Choice Prints: Recent Works by Various Artists, The Print Club Gallery, Philadelphia, Pennsylvania

Four Brothers Press Exhibition of Lithographs, University Club of Chicago

1982

Techniques of Printmaking, Van Straaten Gallery, Chicago

Colored Pencil Drawing Invitational, Sonnenschein Gallery of Durand Institute, Lake Forest College, Lake Forest, Illinois

1981

Contemporary Prints from Landfall Press, Trisolini Gallery, Ohio University, Athens, Ohio (catalogue)

Selected Illinois Artists, Evanston Art Center, Evanston, Illinois

New Work, G. W. Einstein Company, Inc., New York

Nine from Einstein, Inc., Signet Art, Kamp Gallery, St. Louis

Recent Acquisitions, Illinois State Museum, Springfield

Still Life, Members' Gallery, Albright-Knox Art Gallery, Buffalo, New York

Edition 12, Reicher Gallery, Barat College, Lake Forest, Illinois

Prints and Multiples: The 79th Exhibition by Artists of Chicago and Vicinity, Art Institute of Chicago (catalogue)

1980

Still Life, Kent State University Gallery, Kent, Ohio

1979

The New American Still Life, Westmoreland County Museum of Art, Greensburg, Pennsylvania (catalogue)

Recent Publications, Landfall Press Gallery, Chicago

Modern Art in Toledo Collections, Toledo Museum of Art, Toledo, Ohio (catalogue)

New York, G. W. Einstein Company, Inc., New York

1978

Seven Artists: Contemporary Drawings, Cleveland Museum of Art, Cleveland (catalogue)

Three Realists, Canton Art Institute, Canton, Ohio

Recent Acquisitions, National Museum of American Art, Smithsonian Institution, Washington, D.C.

First Anniversary Exhibition, Hull Gallery, Washington, D.C.

1977

Galex Art Exhibition, Galesburg Civic Art Center, Galesburg, Illinois

1976

N.A.M.E., ARC and Artemesia Invitational, Chicago

Illinois Invitational, Illinois State Museum, Springfield

New Horizons in Art, North Shore Art League, Mid-Continental Plaza, Chicago

1975

National Drawing Competition, Cheney Cowles Memorial Museum, Spokane, Washington

1974

Women Present Women, North River Community College, Chicago

PUBLIC AND CORPORATE COLLECTIONS

Albright-Knox Art Gallery, Buffalo, New York

American Express, Minneapolis

American Telephone and Telegraph Corporation

The Arkansas Arts Center, Little Rock

Arthur Anderson, Chicago

Art Bank, Department of State, Washington, D.C.

The Art Institute of Chicago

Ball State University Museum of Art, Muncie, Indiana

Bank of America, San Francisco

David Winton Bell Gallery, Brown University, Providence, Rhode Island

Mary and Leigh Block Gallery, Northwestern University, Evanston, Illinois

Brauer Museum of Art, Valparaiso Center for the Arts, Valparaiso, Indiana

Captiva Corporation, Denver, Colorado

Canton Art Institute, Canton, Ohio

Chapman, Cutler, Chicago

Chase Manhattan Bank, New York

Chicago Tribune

Cleveland Museum of Art

Davenport Museum of Art, Davenport, Iowa

Elvehjem Museum of Art, University of Wisconsin–Madison

Federal Reserve Board, Washington, D.C.

Fine Arts Gallery, Vanderbilt University, Nashville, Tennessee

First Illinois Bank of Evanston

FMC Corporation, Chicago

Fogg Art Museum, Harvard University, Cambridge, Massachusetts

General Electric, Fairfield, Connecticut

General Mills, Golden Valley, Minnesota

W. W. Grainger, Chicago

Hallmark Cards, Inc., Kansas City, Missouri

The Harris Foundation, Chicago

Harvard University, Cambridge, Massachusetts

Hunter Museum of Art, Chattanooga, Tennessee

Illinois State Museum, Springfield

Indianapolis Museum of Art, Indianapolis, Indiana

Herbert F. Johnson Museum of Art, Cornell University, Ithaca, New York

Kansas City Art Institute, School of Design,
Kansas City, Missouri

Kemper Insurance Company, Long Grove, Illinois

George S. May International, Park Ridge, Illinois

The Metropolitan Museum of Art, New York

Milwaukee Art Museum, Milwaukee, Wisconsin

Minneapolis Institute of Arts

National Gallery of Art, Washington, D.C.

National Museum of American Art, Smithsonian
Institution, Washington, D.C.

The Nelson-Atkins Museum of Art, Kansas City,
Missouri

New York Public Library

Nippon Lever Corporation, Tokyo

Oak Brook Bank, Oak Brook, Illinois

Ortho-Tain, Inc.

Owens-Corning Fiberglass Corporation, Toledo,
Ohio

Owens-Illinois Incorporated, Toledo, Ohio

Roll International, Los Angeles

Roswell Museum and Art Center, Roswell, New
Mexico

David and Alfred Smart Museum of Art,
University of Chicago

Snite Museum of Art, University of Notre Dame,
Notre Dame, Indiana

Spencer Museum of Art, University of Kansas,
Lawrence

Union League Club of Chicago

University of Arizona Museum of Art, Tuscon

Western Electric, Chicago

Wichita Falls Museum and Art Center, Wichita
Falls, Texas

Yale University Art Gallery, New Haven,
Connecticut

TEACHING

2000

Visiting professor, Art Theory and Practice,
Northwestern University, Evanston, Illinois

1999

Artist-in-residence and workshop, Anderson
Ranch Arts Center, Aspen, Colorado (also 1997)

1998

Visiting artist, Fort Lewis College, Durango,
Colorado

1997

Artist-in-residence, Northwestern University,
Evanston, Illinois

1996

Lecturer, Cleveland Museum of Art

Artist-in-residence and lecturer, Columbia
College, Chicago

1995

Lecturer, University of Wisconsin–Milwaukee

Lecturer, Snite Museum of Art, University of
Notre Dame, Notre Dame, Indiana

1994

Lecturer, Emporia College, Emporia, Kansas

Lecturer, Glenbard High School, Lombard, Illinois

1993

Lecturer, Alder Institute, Chicago

1990

Artist-in-residence, Oklahoma Arts Institute,
Quartz Mountain State Park, Lone Wolf

Lecturer, Sun Foundation Center, Peoria, Illinois

Lecturer, Willowbrook High School,
Willowbrook, Illinois

1989

Guest artist in printmaking, University of Texas
at Austin

1988

Artist-in-residence, Southern Illinois University,
Carbondale

Lecturer, Lyons Township High School, Lyons
Township, Illinois

Lecturer, Oak Park–River Forest High School,
Oak Park, Illinois

1986

Artist-in-residence, University of Notre Dame,
Notre Dame, Indiana

Lecturer, teacher workshop on still life, Art
Institute of Chicago

Art consultant, Art Department, Oak Park–River
Forest High School, Oak Park, Illinois

Artist-in-residence, University of Regina, Regina,
Canada